IMAGES
of America

LIGHTHOUSES
AND LIFE SAVING
ALONG THE MAINE AND
NEW HAMPSHIRE COAST

NOTICE TO MARINERS.

NEW LIGHT-HOUSE

ON

BASS HARBOR HEAD, MAINE.

FIXED RED LIGHT.

A new light-house is now in course of construction on BASS HARBOR HEAD, the eastern side of the entrance to BASS HARBOR, MOUNT DESERT ISLAND, MAINE. The tower is cylindrical, built of brick, is 21 feet high, will be painted *white*, and the lantern will be painted *black*.

The dwelling house will be of wood, and with the walk connecting it with the work-room of the tower will be painted *brown*.

The illuminating apparatus will be a catadioptric lens of the 5th order of the system of Fresnel, showing a *fixed red* light.

The focal plane will be 26 feet above the ground, and 56 feet above the level of the sea, and the light should be seen in ordinary states of the atmosphere, from the deck of a vessel, 13 nautical miles.

The approximate position as given by the best authorities that can be obtained is—

Latitude, 44° 14′ 30″ North.
Longitude, 68° 23′ 10″ West of Greenwich.

The following magnetic bearings and distances have been taken from the light-house:

York's Narrows, W. ⅛ S., 7 miles.
Little Duck Island, S. E. ¼ S., 5 miles.
Long Ledge Buoy, E. by S., 3 miles.
Edgemoggin Light-house, N. W. ¾ W., 10 miles.

The light will be lighted for the first time at sunset on Wednesday, the 1st of September next, and will be kept burning during every night thereafter from sunset to sunrise.

By order of the Light-house Board:

W. B. FRANKLIN,

Secretary.

TREASURY DEPARTMENT,
Office L. H. Board, May 20, 1858.

Shown above is the original Light-House Board's Notice to Mariners, May 20, 1858.

IMAGES
of America

LIGHTHOUSES
AND LIFE SAVING
ALONG THE MAINE AND
NEW HAMPSHIRE COAST

James Claflin

ARCADIA

Published by Arcadia Publishing,
an imprint of Tempus Publishing, Inc.
2 Cumberland Street
Charleston, SC 29401

Printed in Great Britain.

Library of Congress Catalog Card Number: Applied for.

For all general information contact Arcadia Publishing at:
Telephone 843-853-2070
Fax 843-853-0044
E-Mail arcadia@charleston.net

For customer service and orders:
Toll-Free 1-888-313-BOOK

Visit us on the internet at http://www.arcadiaimages.com

This book is dedicated to the heroes of all services everywhere who risk their lives for others.

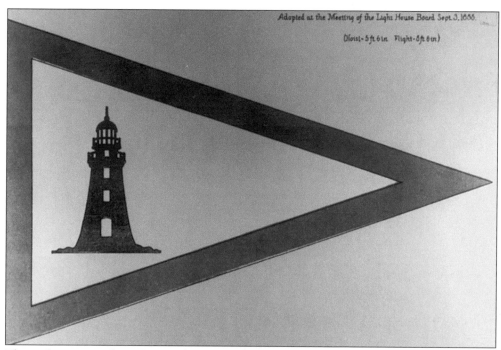

This is the pennant flown by vessels of the United States Light-House Establishment.

CONTENTS

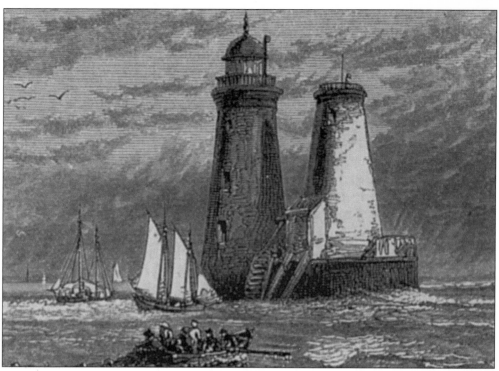

Pictured above is an early engraving of Whaleback Light.

Acknowledgments

Although the majority of the photographs and images used in this volume are from the author's collection, I could not have put this volume together without the kind and able assistance of a number of other individuals and institutions. First, thanks should go to my dad, Kenrick A. Claflin, who passed on to me the love and appreciation of history, and of tradition. To Jamie and Joshua, who are sons to be proud of and who carry on the traditions, and to Margie, who said "yes" and who makes it all worthwhile.

Thanks also to Ralph and Lisa Shanks, for their continued encouragement and support and the loan of their fine photographs, and to Wick York for his advice and encouragement. Thanks to Glenda Bourque for her continued encouragement; to Christinea Gentilucci for her proofreading, her many suggestions, and her patience; to Andy and Anita Price, maritime antiques dealers, for their friendship and encouragement and for the loan of photographs from their collection; and, as always, to Mr. Ken Black of the Shore Village Lighthouse Museum, a true gentleman. In addition, thanks should go to the following individuals for the loan of photographs used in this book: Mr. Colin Mackenzie of the Maritime Research Center in Petaluma, CA; Mr. John Hutchinson; Mr. Raymond A. Herberger, Ms. Lucinda Herrick, U.S. Coast Guard Academy Museum; and to Mr. William P. Quinn. Also, a special thanks to Gordon Benoit for providing a number of images from his web site, Sue Dwyer and Sandra Shaw for looking through their files, and Joe Lebherz of the Maritime Research Center.

My sincere thanks to all. You were most kind and generous, and you took the time when I asked. And finally, I would like to express my sincere gratitude to all of the lighthouse keepers, life savers, and Coast Guard personnel and their families, for you all have set the standards.

INTRODUCTION

The United States Coast Pilot for 1933 notes that the Atlantic coast of Maine and New Hampshire ". . . is generally rocky and indented and broken by . . . numerous large bays and many excellent harbors. Numerous islands lie along the shore, among which are passages that are much used by vessels. The many boulders, rocks, and ledges which lie along the coast require the closest attention of the navigator, as in many cases they rise abruptly from deep water" Farther south, the coast ". . . is more thickly settled, several beaches being popular resorts. The coast here is generally lower and sandy, with fewer outcropping ledges and outlying dangers." Fogs, the dread of every navigator, are of frequent occurrence in this region and there are many periods of much thick weather. Heavy gales, common during the winter months, are generally from northeastward and may occur at any time.

For more than two centuries, from remote St. Croix River in the north, to Matinicus Rock far at sea, and south to Hampton Beach on New Hampshire's south coast, more than 83 lighthouses and life-saving stations have guarded the coast to guide and rescue mariners. Whether marking locations in a "pea soup" fog or storm or rescuing a ship's crew when disaster struck, these remote stations have served innumerable vessels over their long existence. Hour by hour, day by day, thousands of craft relied on the men and women who manned these outposts.

There is a flavor to the New England coast that these sentinels remind us of—a simplicity and a depth of historic value. Even today, as one cruises by stately Boon Island Light, towering 137 feet over the sea, it is easy to feel oneself back a hundred years ago. Seafaring is not all that different today, for it still reduces to one's own ability pitted against the elements.

Think of the best of some of these beautiful stations: Portland Head Light built in the term of President George Washington; Seguin Light, the highest on the coast (though not the tallest); Fort Point Light, where the light keeper's livestock grazed on the grounds of old Fort Pownall; the storm-swept Life-Saving Service station on Appledore in the Isles of Shoals, discovered by Capt. John Smith in 1614; and many others that have withstood the elements in their isolated locations along the coasts. Their image has become synonymous with security and integrity, and just as Americans have always held a fascination for the sea, so too have they admired the keepers of these silent sentinels along the shore—the lighthouses and life-saving stations. Today, we long to remember the ways of the men and women that tended the lighthouses and lightships, and patrolled the beaches. These men and women were devoted to duty; they were

heroes to many as they kept their long vigils, and they gained a fine reputation for their heroism and steadfastness.

"Hundred-harbored" Maine and New Hampshire, with their historic ports and sandy beaches, have attracted thousands of visitors for over a hundred years and have always derived much of their goods and income from their extensive coastal commerce. Hundreds of shipwrecks occurred off the coasts with startling losses. During the colonial years, each of the 13 colonies established lighthouses and other navigational aids according to their needs. The first lighthouse in the colonies was first lit in Boston Harbor on Little Brewster Island, in 1716. As time went on, the need for more beacons was realized, and additional lights were established at Portsmouth in 1771, on Portland Head in 1791, at lonely Seguin in 1797, and on Matinicus Rock in 1827.

As commerce increased and shipwrecks with attendant loss of life became more numerous, the newly formed federal government realized that a more coordinated system of lighthouses, lightships, and navigational aids was needed. Thus, in 1789, Congress acted to place the responsibility for all navigational aids under the federal government. Unfortunately, during this period, economy of operation ruled over efficiency, causing the lighthouses of the United States to become some of the poorer quality in the world. Many concerns were voiced until, in the 1850s, the new Light-House Establishment was formed under an administrative board. Thus began a new era of high quality and efficiency that continued into the 1930s, when the Coast Guard assumed responsibility.

At about the same time the colonies were realizing a need for navigational aids, the citizens of Massachusetts were becoming more concerned with the incidents of shipwreck and loss of life along the coast. Although a coordinated system of lighthouses and lightships helped many mariners find their way clear of treacherous shoals and sand bars, the inevitable shipwreck did occur as the fog and New England weather forced ships ashore with repeated loss of life. Sometimes, shipwrecked sailors were able to make their way ashore, only to perish from lack of shelter on the desolate beaches.

Prominent citizens of the day were beginning to appreciate the need for a system of shelter and rescue for mariners driven ashore, and in 1785, an organization called the "Massachusetts Humane Society" was founded. Soon began what would become the foundation of the American system of rescue from shipwreck. Based on the British model, the Humane Society began to establish huts of refuge and lifeboat stations along the shore but just as with the lighthouses, a more efficient and coordinated system was needed as our maritime trade continued to expand.

After a number of spectacular shipwrecks with attendant loss of life, Congress, in 1871, finally appropriated funds to create a coordinated system of life saving, and by the late 1870s, Sumner Increase Kimball would take over as its superintendent. In a short time, Sumner Kimball would produce a model service that would last for 45 years and boast an unprecedented record of rescues, service, and organization. In 1915, the U.S. Life-Saving Service would be merged with the Revenue Cutter Service to continue the fine record as the U.S. Coast Guard.

Though many of the early lighthouses and life-saving stations no longer exist, and their crews have long since given up the oil can or Coston flare, their stories remain forever in the official records and in photographs. These remote locations were more than their job sites. They were home to the men and their families. Indeed, many of the families played vital roles in maintaining the lights and performed spectacular rescues when the keepers were caught away during storms. Through the wonderful photographs that remain today, we can get a glimpse into the everyday life of these dedicated men and women of the government service.

As you turn these pages, please think of the lives that they led—the standards of excellence and devotion to duty that they set—and enjoy the voyage.

One

THE EARLY YEARS

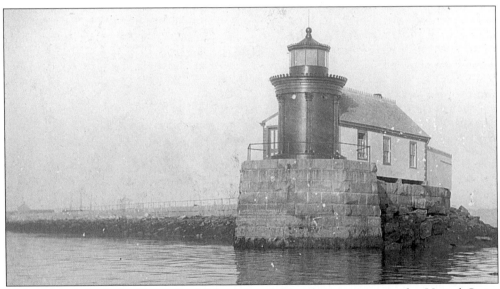

The study of the Light-House Establishment and life-saving services in the United States presents a wealth of activities and information that draws the student through over 250 years of history. In the early years, before the American Revolution and the organization of a centralized federal government, the services provided were haphazard at best. The few lights for navigation that did exist might be installed by a group of sea captains, realizing the need but having no organization charged with the responsibility, or later by the individual states. In the 1700s, the state governments, when put under sufficient pressure from ship owners and merchants, began to establish some beacons in strategic locations. What few lighthouses that did exist were poorly constructed and little maintained. By the 1790s, it was becoming apparent that the "system" of lights in the country was wholly inadequate and greatly inferior to most other maritime nations. One of the first acts by the newly formed federal government was to take over control of the lighthouses in the former colonies, forming the basis of the country's lighthouse system. Shown above is Portland Breakwater Light, c. 1880.

Treasury Department,

July 16" 1872/.

Sir:

You are hereby appointed — — Keeper of the Light-House at Wood Island Maine , at a Salary of Five hundred and twenty dollars per annum vice Edwin Tarbox resigned.

I am, very respectfully,

Wm A. Richardson
Acting Secretary of the Treasury.

Mr. Albert Norwood

Compounding the lighthouse problem in the United States was the system of political patronage prevailing at the time. By the early 1800s, the President of the United States and the secretary of the Treasury made the appointment of lighthouse keepers based on the local recommendation of influential public officials. Following presidential elections, if the political party in the White House changed, many times, so too did the secretary of the Treasury and thus, many of the light keepers. Reading the records of the early years often reveals keepers serving for a few years, only to be replaced after an election, and sometimes, returning after their political party returns to office. The overall effect of these procedures was that the lighthouses were often manned by poorly trained, unskilled persons, if manned at all—and some were becoming disgruntled with the system. Occasionally, a sea captain would approach a landfall to find the light emitted from the lighthouse of very poor quality or even unlit or abandoned. Shown above is an original letter appointing Albert Norwood as keeper at Wood Island Light, July 16, 1872.

By 1840, Congress had begun to recognize the importance of an organized system of navigational aids to the growing maritime nation and soon began to enlist a number of engineers to study the existing system, and to make recommendations. In 1852, a comprehensive, 760-page report was issued, with one of its primary recommendations being the appointment of an independent Light-House Board to organize and coordinate the nation's system of aids.

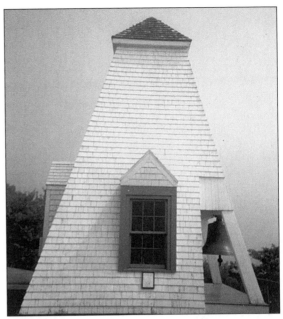

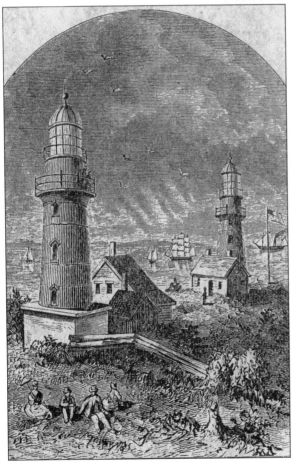

With the adoption of the Light-House Board, a system of order was finally brought to the lighthouses and navigational aids in the country. Many new lighthouses, beacons, and buoys were constructed, and maintenance was improved on existing stations. New fog signals and light vessels were added, and many new programs were instituted to study and improve the equipment in use. Shown is an early engraving of Cape Elizabeth twin lights, c. 1870.

One benefit of the new Light-House Board was the improvement of the personnel administration and thus the improvement of the morale within the organization. Experience and ability now became a determining factor in keeper appointments. As the working conditions improved, so did the lives of the keepers; many of them would begin long careers. From this point on, the position of lighthouse keeper gained importance and respect. Many keepers and their families served up to 50 years. With these new regulations came strict attention to detail. Rules were implemented that required keepers to be neatly and completely uniformed, and inspections were made by the district inspector to ensure that the station was in good order. However, by this time, the keepers were happy to be a part of the organization, and they wore their uniforms with dignity, as many early photos of the day suggest. Note the insignia on this keeper's collar. A "K" within the insignia would indicate that he is the principal keeper, with assistants wearing a number 1 or 2. Note also the gold-plated Light-House Establishment insignia with crossed buoys on the keeper's hat. This c. 1880 photo was made by Abbey Studios.

The earliest lights used to guide mariners along the coast consisted of crude towers supporting a wood or pitch-fed flame, and later tallow candles. By the 1820s, the federal government began using a lantern fueled by whale oil and fitted with a glass magnifying lens designed by Winslow Lewis. By the 1850s, with the advent of improved glass optics invented by Augustin Fresnel, the Light-House Board began to refit America's lighthouses with the improved and more powerful Fresnel arrangement.

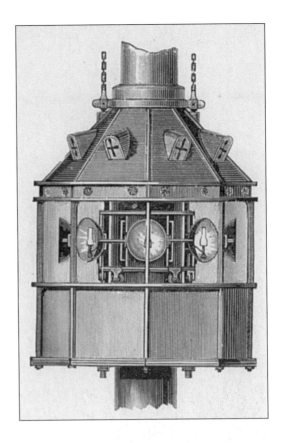

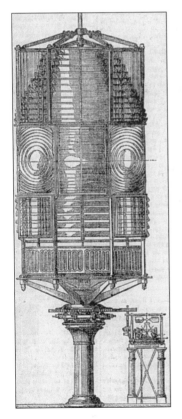

By the 1870s, the Light-House Board was continuing to experiment with new methods of lighting, including new lamps with different types of oil and fuel. One of the most important advancements adopted by the new board was an invention by Frenchman Augustin Fresnel that concentrated the lost rays of light from the oil lamps into a powerful beam. This new Fresnel lens of glass prisms would completely revolutionize the Lighthouse Establishment.

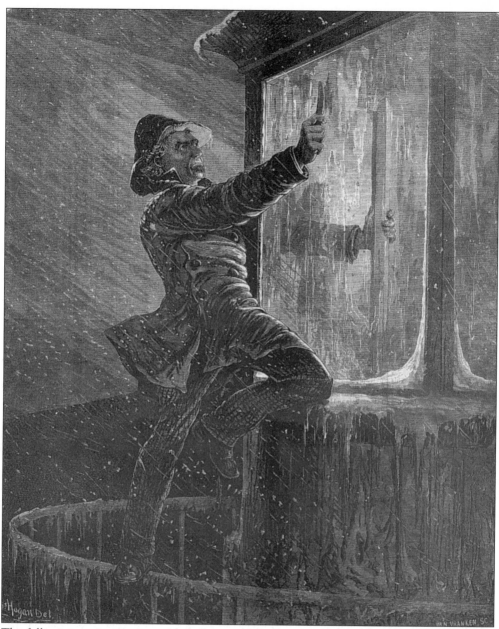

The following are instructions to light keepers from the U.S. Light-House Board in 1902: "All keepers at light-stations shall wear a uniform in accordance with the uniform regulations issued by the Board. The utmost neatness of buildings and premises is demanded. Lights must be lighted punctually at sunset, and must be kept burning at full intensity until sunrise. The lens and the glass of the lantern must be cleaned daily and always kept in the best possible condition. Utensils of all kinds must be kept in their proper places. The revolving clockwork must be kept carefully from dust. The chariot or carriage upon which the lens revolves must be carefully wiped and the rollers properly oiled." (*Harper's Weekly*, December 30, 1876.)

The Light-House Board organized the country into 15 Light-House Districts, each with depots to supply the lighthouses. Maine and New Hampshire comprised the First District, and the depots included Little Hog Island in Portland Harbor, Little Diamond Island, Whitehead, and Bear Island. From these depots, tenders would service the light stations and perform other maintenance. Lighthouse tenders were all named for flowers including the *Iris*, *Myrtle*, *Lilac*, and *Geranium*. Note the Light-House Service emblem on the bow. (Photo of *Azalia c.* 1891, courtesy Shore Village Museum.)

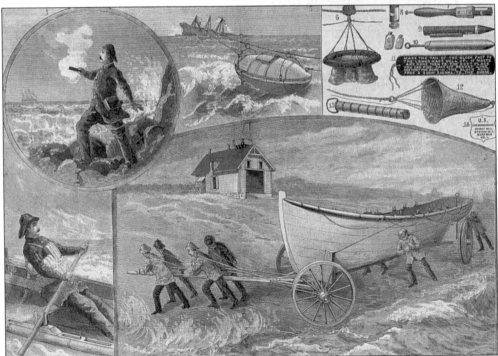

Much like the lighthouses, the establishment of life-saving services to rescue and provide succor for shipwrecked sailors has a history of over 200 years. Formed in the 1780s, the Massachusetts Humane Society first attempted to provide relief for victims of shipwreck by erecting huts for shelter along the Massachusetts coast. Later, the first lifeboat station would be erected at Cohasset, and by the 1840s, others would be erected and fitted out with boats and other apparatus. More was still needed, however. (*Scientific American Supplement*, February 6, 1892.)

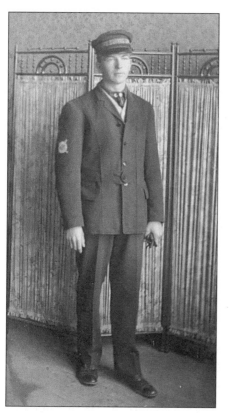

The formation of a national life-saving service traces its origin to the slow legislative process in Congress. In 1847 and 1848, Representative William A. Newell secured appropriations, and the first life-saving stations were constructed along the coast of New Jersey, under the jurisdiction of the U.S. Revenue Cutter Service. The stations were fitted with iron surfboats, mortars, and other necessary equipment, but it would be decades until a nationwide system would be put in place.

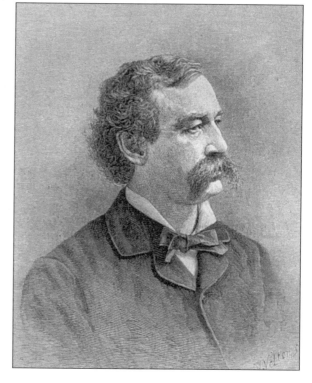

Unlike the Light-House Establishment, the early years of the U.S. Life-Saving Service set the tone for many years to come. Key to the success of the Life-Saving Service and its fine reputation was the appointment of Sumner Increase Kimball as its general superintendent. Under Kimball's expert management, this service would become a model of efficiency and honesty and accrue a record of rescues and lives saved second to none. (*Harper's New Monthly*, February 1882.)

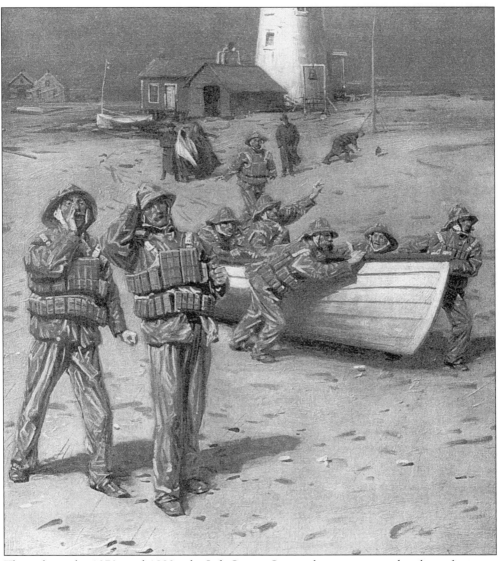

Throughout the 1870s and 1880s, the Life-Saving Service began to expand its line of stations along the coast. From an occasional house of refuge or boat station manned by dedicated volunteers, Kimball began to add new stations manned by paid, well-trained crews. These additional stations soon began to pay dividends as the tragic toll from shipwrecks soon began to stabilize, and then fall, for the first time in years. By 1914, the First Life-Saving District, comprising the coast of Maine and New Hampshire, would boast 15 stations, each spaced approximately 4 to 6 miles from the next or located in areas of particular need. (*Collier's Weekly*, December 24, 1898.)

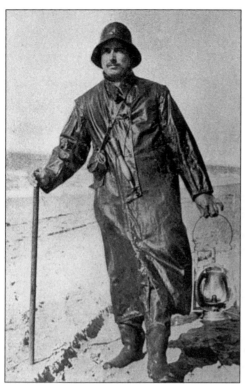

Life-saving stations were manned by a keeper and a crew of five to eight surfmen. These well-trained and experienced men maintained daily watches for vessels in distress from the station's watch-tower and, by night, patrolled the beaches. When a wreck was spotted on patrol, the surfman would ignite his red Coston signal flare both to alert the tower watchman and as a signal to the survivors that help was on the way.

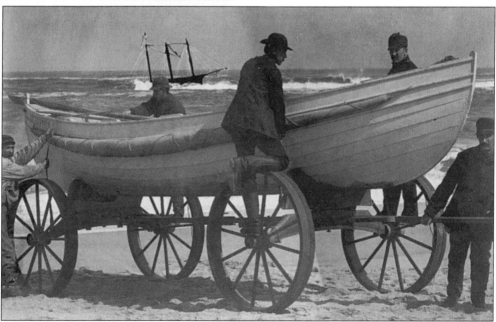

Upon being alerted to a vessel in distress, the station keeper would decide how best to make the needed rescue, which would usually depend on the distance of the wreck from the beach. The three methods of rescue at the keeper's disposal would usually be breeches buoy, life-car, or rescue by surfboat. Breeches buoy and life-car were used when the vessel was within 600 yards from the beach.

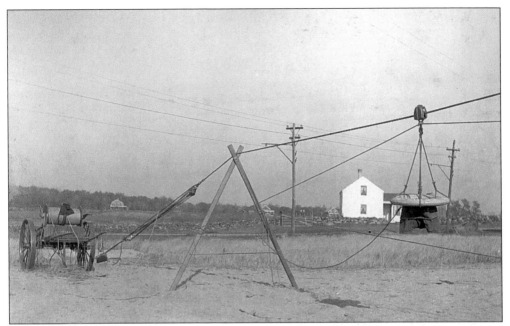

When the breeches buoy was chosen, the surfmen would harness themselves to the apparatus for the long pull down the beach. On the beach apparatus cart were coiled reels of shot line, heavy hawser, as well as faking boxes to keep the coiled line from tangling. To gain access to the vessel with a line, a small bronze cannon or Lyle gun was used. The men shown in these photographs were Rye Beach Life Savers. (Clarence N. Trefry photo, c. 1880.)

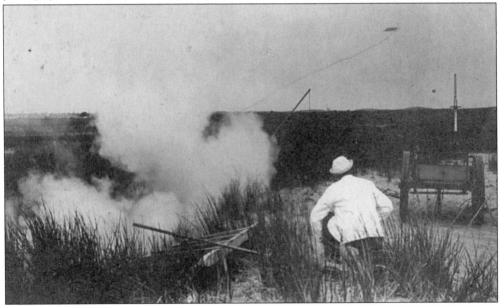

Iron projectiles were fired into the rigging of the vessel, which carried a small shot line. Surfmen were adept at judging winds and seas and were able to direct the projectile with great accuracy. Sailors on the stricken vessel would use the shot line to haul aboard the larger hawser and make it fast on the ship's mast. A life-ring with attached canvass pants, or breeches buoy, was then sent out and the sailors were pulled to safety. (Photo c. 1894.)

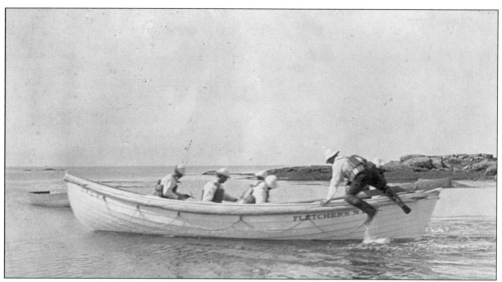

Many times, the shipwreck would be too far offshore to be reached by the Lyle gun, in which case the surfboat or lifeboat would be used. This, too, would be hauled on its four-wheeled carriage to a point suitable for launching. Watching for the proper time, the keeper would direct his men to push the boat into the water, climb in, and begin to "pull" toward the wreck. Shown is the Fletcher's Neck crew *c.* 1916.

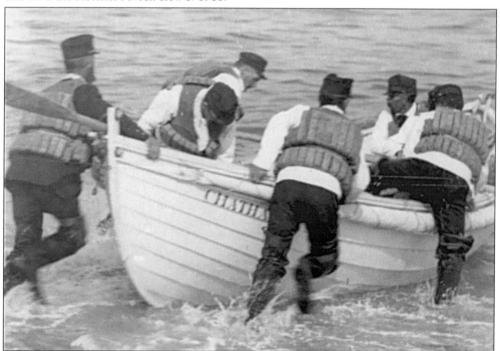

When launching the surfboat, timing with the breakers was critical, and many surfboats were overturned or wrecked in the breakers. After rowing for hours, the men would finally begin to approach the wrecked vessel. The keeper would draw on his years of experience and knowledge of the sea to approach the wreck in such a way so as not to be dashed to pieces against its side, and yet somehow still remove the sailors from the rigging.

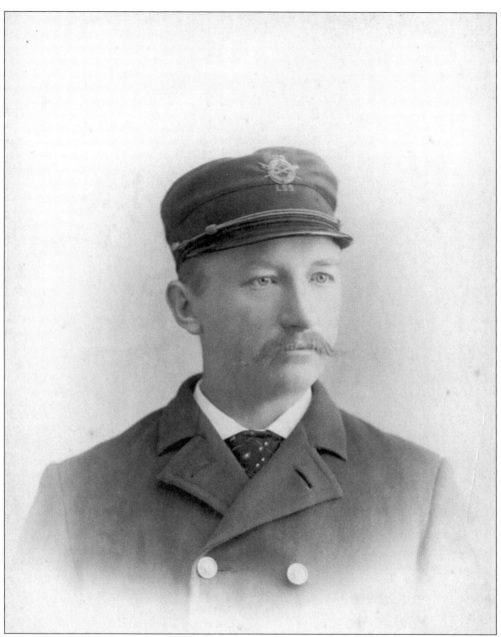

During its existence, the Life-Saving Service built up a tremendous rescue record, though sometimes with the loss of their own men. Many books such as *Storm Fighters*, *Heroes of the Surf*, *Guardians of the Sea*, *Uncle Sam's Life-Savers*, *Rulers of the Shoals*, and others were written about these heroic life savers as they brought back hundreds of sailors and passengers from the clutches of the sea. Without hesitation, the crews would go out through hurricanes, blizzards, and the fiercest of seas. The 1899 Regulations of the Life-Saving Service, in Article VI, Section 252, required that the men attempt the rescue and that the keeper ". . . will not desist from his efforts until by actual trial the impossibility of effecting the rescue is demonstrated." But nowhere in the regulations did it say that the men had to come back—and some did not. (L.V. Newell photo, c. 1880.)

Surfmen were quite proud of their profession. The men constantly repaired and painted where needed and were always ready to pose for the camera. Here, life savers take a break from their duties to pose in their white summer uniforms at a New England station in the 1890s. Just behind can be seen the station's cistern, which was used to collect and store rain runoff from the station roof to serve the station's needs.

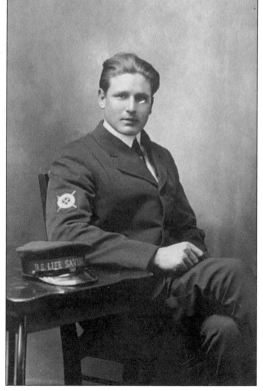

The Life-Saving Service Regulations were quite detailed, requiring that the men always be proficient at their tasks and be able to fill any position. Each day's activities were specifically laid out in the rules: Monday, station cleaning and maintenance; Tuesday, drill in launching and landing the surfboat; Wednesday, signal flag communications; Thursday, drill with beach apparatus and breeches buoy; and so on. Saturday was for wash and Sunday for religious pursuits. Shown is Surfman Frank Wagner, c. 1890.

Two

DOWN EAST

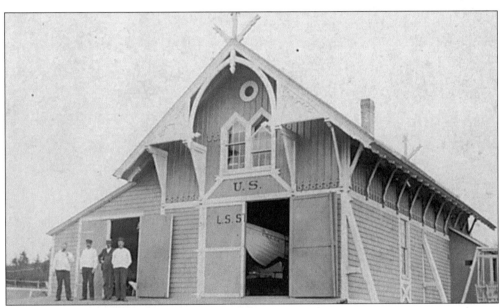

The Maine coastline grows more rugged as one travels north from Narraguagus Bay, and upon reaching Eastport, the cliffs are bold and awesome and the seas begin to show the characteristic Bay of Fundy energy. Wrecks have occurred here in all seasons, at practically all locations and on nearly every offshore rock.

The Quoddy Head Life-Saving station was located in Carrying Point Cove, near Lubec, and was the easternmost life-saving station in the country. The ornate structure is known as an 1874-type station, one of only 25 built in the country. The station at Quoddy Head was built in 1873–74 and combined trim detailing of the Carpenter Gothic and Stick Style architecture, common in Victorian America. As was common to the Life-Saving Service, all stations had a roof observation platform from which lookouts could scan the horizon for vessels in distress. Surfmen here were generally employed from August 1 until May 31, with an additional "winter man" added during the harshest weather from December to April. The station here was later replaced in 1918 with a design of the Chatham type.

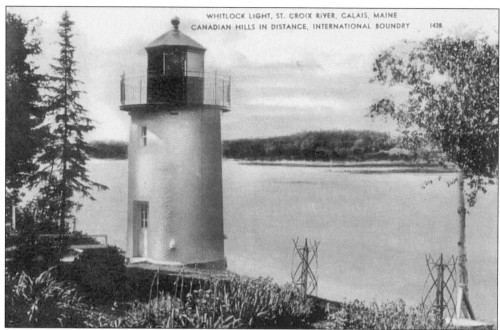

Whitlock's Mill Light began as a crude beacon erected on the south side of the Calais River in 1892. In 1910, the light was rebuilt as a white conical tower under the administration of Pres. William H. Taft, and remains today as the northernmost light in the United States. The light operated only seasonally, closing when the river was frozen over. Today, the station is owned by the St. Croix Historical Society. (American Art view, c. 1920.)

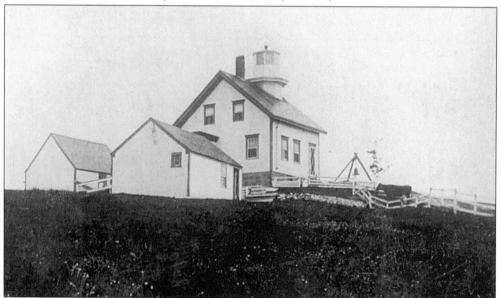

The St. Croix River Light was a fifth-order fixed light situated on Dochet's or Demont's Island bordering the St. Croix River. Years ago, explorer Samuel Champlain made this little island his headquarters from which he explored westward up the Penobscot River. This lovely little island, with plentiful vegetation and good soil for a garden was, for years, a sought-after post by light keepers who were accustomed to the more dangerous offshore posts.

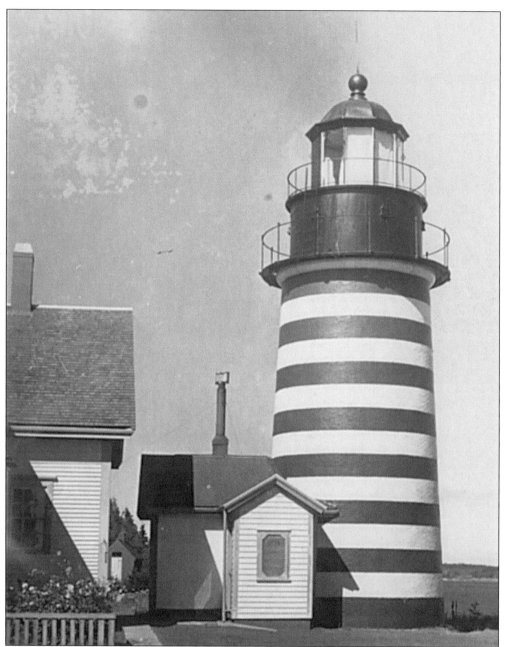

By 1806, it became apparent that a lighthouse was needed near Passamoquoddy Head, and by 1808, the light tower was completed. Thomas Dexter was appointed its first light keeper at an annual salary of $250. Since no dwelling was provided, Dexter was forced to reside some distance away and walk to the station. The present tower was erected in 1858 and was easily identified from an early date by its characteristic red and white bands. In the 1920s, thanks to an early gift from radio manufacturer Atwater Kent, who summered in the area, the family at West Quoddy Head enjoyed long-distance radio reception from its inception. Mr. Kent provided early radio equipment to a number of light stations in the area, making the long winter evenings much more enjoyable for the local families.

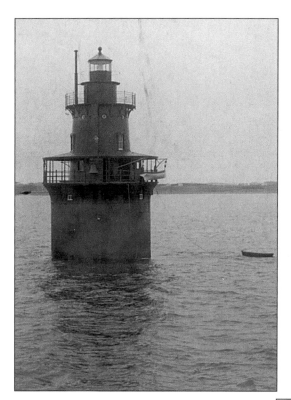

Lubec Narrows, or channel light, is a caisson-style light located on the western edge of the channel marking the entrance into the town of Lubec. Hundreds of inhabitants here worked in the giant canning factories during the early part of the century, necessitating this beacon to mark the channel. This type of lighthouse was known as a "stag" station and was manned by only two keepers, as there was not sufficient room within the light for family quarters.

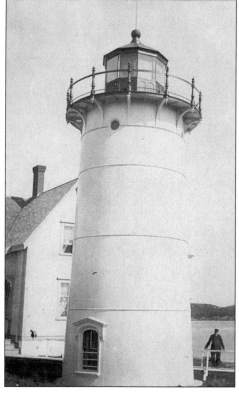

In 1851, Maine boasted 33 lighthouses, each staffed with one keeper. The keepers earned from $300 per year, to a high of $600 per year, for the keeper at Mount Desert Rock Light. During this period, New Hampshire had four light stations in service, with the keepers at the offshore lights each earning the high of $600 per year. By 1900, the number of light stations in Maine had risen to 61. Shown is Little River Light c. 1900.

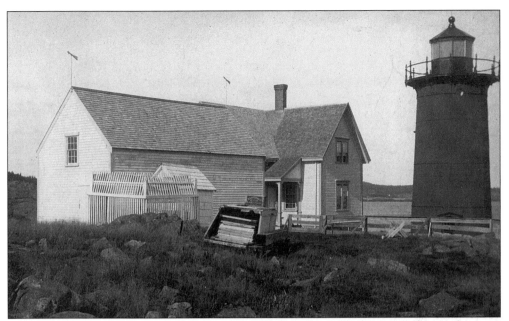

Little River Light marks the entrance to Cutler Harbor. The station here is located on a small island and is second only to Quoddy Head Light in being the farthest eastern light station in Maine. The first tower here was built in 1847 and lasted until 1876, when the present cast-iron tower was constructed. The old fog bell, rung by the keepers for so many years, can now be seen on display in nearby Cutler.

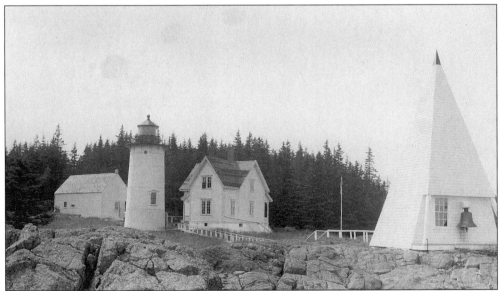

The pyramidal bell tower, like that at Little River Light, has been a common fixture at Maine light stations since the 1870s. Towers may be open or "skeleton" type or enclosed, and are designed to support the weighted cables that drive the Gamewell bell-striking machinery. In time of fog, if the machinery was not functioning, many keepers were faced with the task of striking the bell by hand with a sledge to warn away passing vessels.

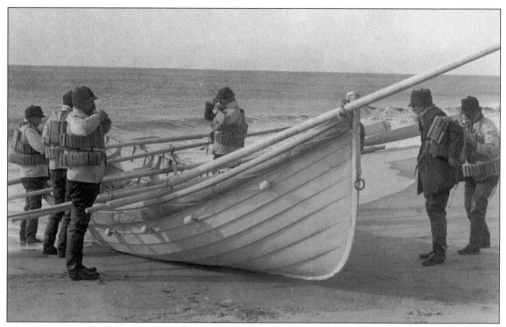

The general superintendent of the Life-Saving Service was Maine native Sumner Increase Kimball. Born in Lebanon in 1834, Kimball graduated from Bowdoin College with a degree in law and then taught school in Maine and on Cape Cod until 1859. In 1871, he was appointed head of the Life-Saving Service, where he would remain until 1915. Kimball was a no-nonsense administrator and is credited with establishing a service second to none. (Underwood view, c. 1900.)

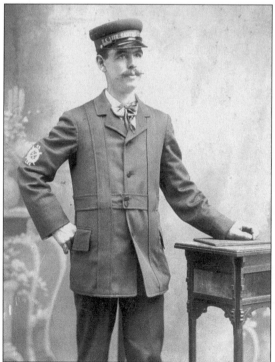

Over its 45-year history, the Life-Saving Service would remain unsurpassed in its record of lives and property saved and would lay the groundwork for what would become today's Coast Guard. Sumner Kimball would remain one of the most respected government administrators, long after his passing in 1923 at age 89. The young New England surfman pictured is a fine example of the proud men that would make up Kimball's organization. (William Mills & Son photo, c. 1880.)

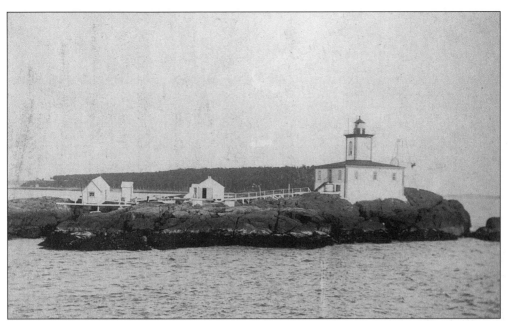

Avery's Rock Light, located in Machias Bay, was constructed in 1875 at the request of President Grant. Due to the extremely exposed location and the small amount of land available, the light tower rises from the center of the roof of the square, white keeper's dwelling. Until the 1930s, when the station was automated, two keepers lived in this sparse environment to keep the light operating.

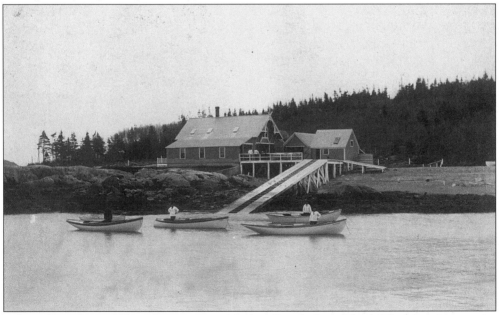

Off Machiasport, near the east entrance to Machias Bay, is Cross Island. The life-saving station was first built here in 1874, as this rocky northern coastline demanded the services of the Life-Saving Service early on. The station is of the expanded 1874-type, with a central boat-room core and expanded "wings" on each side for additional space. Beside the station, leading down from the boat-room, is the long ramp to slide the surfboat or lifeboat into the water.

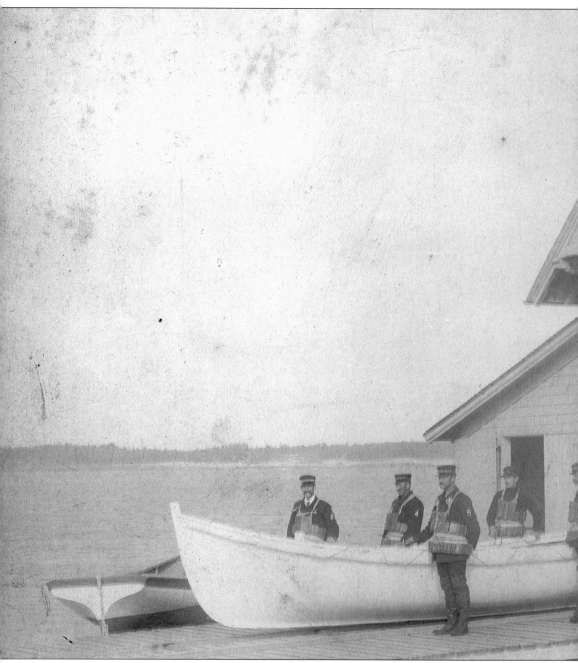

The Crumples Island Life-Saving station, or "The Crumples," was located on a group of islands off Jonesport. It served until 1904, when it was replaced by the Great Wass Island station. The station was typical, with a large boat-room on the first level and a smaller mess-room behind, where the crews assembled and ate their meals. The second floor housed the crew's sleeping quarters and extra cots for survivors. On October 23, 1880, patrolmen on duty here discovered the English brig *Kate Upham* with 11 men on board. She was disabled 3 miles from Red Head, on the easterly point of the island, during a fearful storm. Keeper Hall, seeing no answer to his warning signal hoisted to the masthead, assembled his crew and ran their new surfboat out to

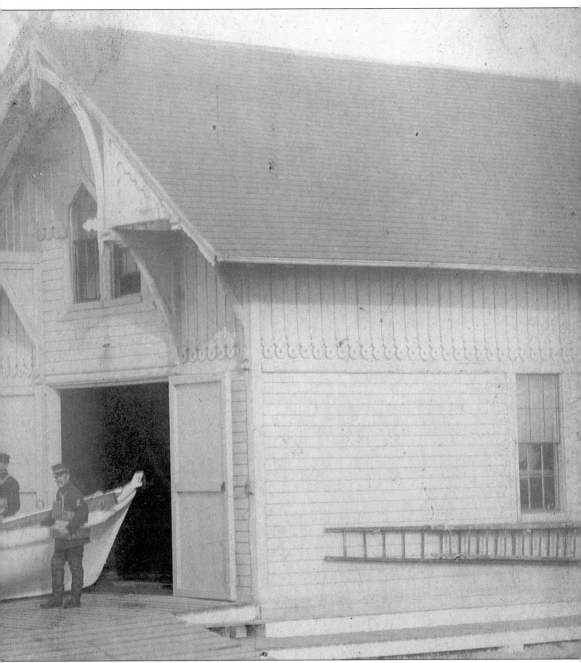

the beach. Grimly watching the fearful storm and sea, and attired in their cork life-belts, the crew launched, determined "to save the brig's crew or go with them." The crew soon entered the breakers, and with a 10-foot-high wall of water smashing at the boat, the crew pulled in a superhuman effort to get to the vessel's assistance. By watching the seas, the keeper was finally able to pull alongside and assist the crew into the boat. Afterward, the captain of the brig related thinking, "Good God, what can that little boat do?" He found this out after an hour-long pull by the surfmen, when he and his men were landed safely on the island.

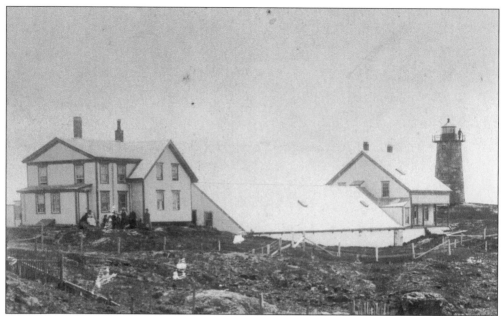

Libby Island Light was for many years known as Machias Light and stood for over 100 years in its original form. The gray granite tower and detached keeper's dwelling served as a guide into Machias Bay and to the entrance to Englishman's Bay from the east. It was here, in 1906, that the three-masted schooner *Ella G. Ellis* came ashore during heavy fog with the loss of all but the captain, who floated ashore on the ship's cabin roof. (Courtesy Andy Price collection, c. 1889.)

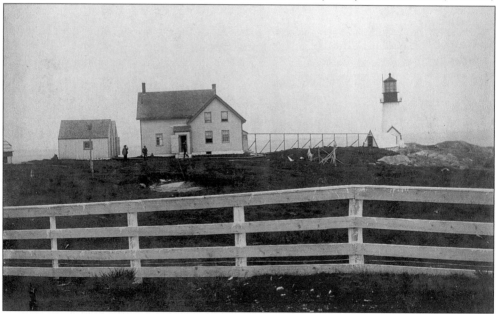

On the eastern end of Mistake Island lies the Moose Peak Light Station, constructed in 1827 when fishing and coastwise trade in the area were at their peak. The light is located in the Moos-a-bec Reach, about 5 miles from Jonesport. For years, it claimed the honor of being the foggiest spot on the Maine coast. In addition to the fog menace, the many treacherous shoals here necessitated the building of a life-saving station on nearby Great Wass Island.

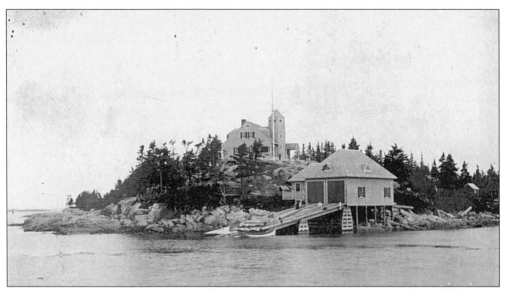

In 1904, a replacement was needed for the Crumple Island station, and a new building was constructed high up on the bluffs on the rocky Great Wass Island. A prominent feature of this attractive station was its octagonal, three-story watch tower rising from the center of the facade and the large bay windows. Close to the water was a two-bay boathouse with a ramp, used to house the station's lifeboat and equipment.

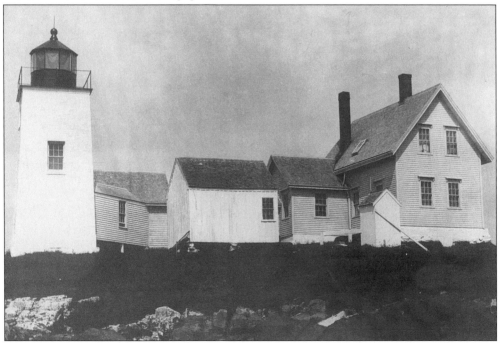

Nash's Island Light is a fixed red beacon on the east side of Pleasant Bay. The light marks the entrance into Moos-a-bec Reach and Harrington Bay. In the 1930s, Capt. John E. Purrington was the keeper here. Blessed with a large family, Keeper Purrington found it necessary to "fit up" a building as a school here and hire a teacher. Later, when the children were of high school age, they boarded in Jonesport for the season. (Coast Guard photo courtesy Joe Lebherz.)

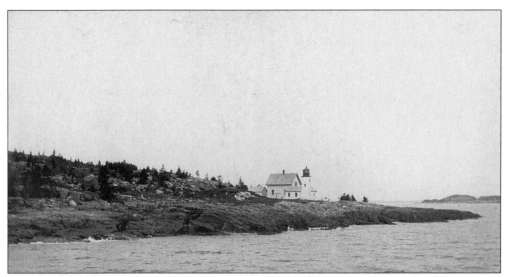

In the 1850s, the area around the Schoodic Peninsula was teeming with shipping and coastal vessels. In 1853, this attractive fifth-order light station was constructed on the southeast point of Pond Island at the entrance to Narraguagus Bay. The station thrived, showing its fixed white light for over 80 years until shipping in the area began to decline in the 1920s. Along with Mark Island Light and Pumpkin Island Light, Narraguagus Light was discontinued and sold in 1934.

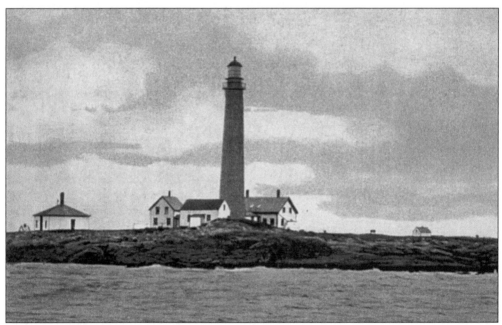

Fourteen miles to the west of Bar Harbor, between Narraguagus and Frenchman's Bay, lies the tiny island of Petit Manan. As early as 1817, a government lighthouse had stood there, but by the 1830s, repairs were needed. In 1855, the present granite tower was constructed, rising 119 feet, second only to Boon Island Light in height. Manning the light here was a dangerous assignment, as great gales swept the island. The beautiful tower survives to this day. (Hugh C. Leighton view, c. 1910.)

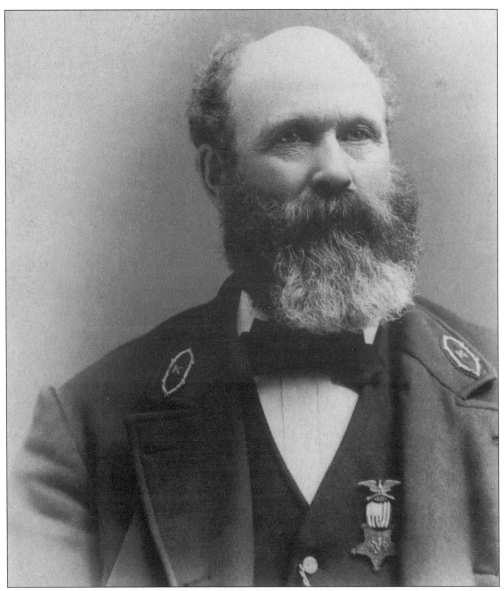

In addition to maintaining the delicate light and fog signal equipment, light keepers must be adept at all aspects of station maintenance. After a difficult winter, keepers are kept busy in the spring with painting and puttying the tower and dwelling, for the harsh Northeast winters take their toll on the structures. Using ropes fitted with a boatswain chair of lumber, the keepers scaled the sides of the tower to apply a fresh coat of whitewash. Breaking seas on New England's offshore islands posed constant hazards, and on many of the offshore stations, keepers were required to make weekly trips to the mainland for food and supplies. On such trips, keepers have been dashed on the rocks or overturned while landing in rough seas. Though remote, life was always a special existence and families generally built a host of cherished memories. Robert Sterling tells of the keeper at the light station on the Kennebec River, who, two or three days before Christmas, spotted a group of large buck deer grazing near the lighthouse. The keeper returned to the light to tell his young children, who were delighted, thinking that Santa Claus was preparing his herd for their evening rounds.

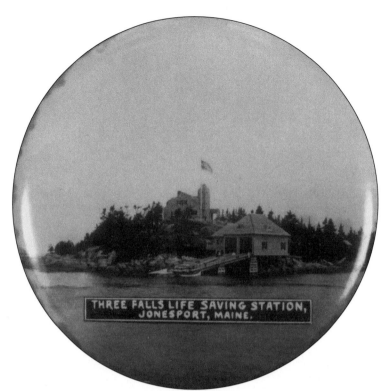

This extremely rare pocket mirror features a hand-colored photograph of the Great Wass Island, or Three Falls Life-Saving station, off Jonesport, Maine. The photo shows the modified Port Huron–type station proudly standing high up on the rocks. The photo measures 2 inches in diameter, the obverse being a pocket mirror for the lady or gentleman. Such turn-of-the-century commemorative items are most rare, especially those associated with life-saving stations.

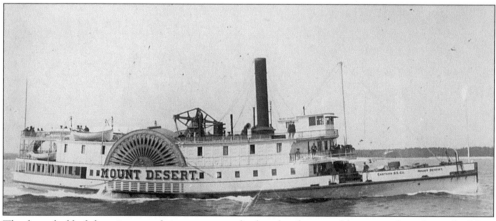

The later half of the nineteenth century was the heyday for travel by steamship along the New England coast, and one of the premier carriers was the Eastern Steamship Company. The company's extensive fleet was comprised of a large number of steamers, from the great steel express boats *Camden* and *Belfast*, to the smaller connecting steamers. Steamers of the era were designed with comfort and convenience in mind and were well known for their excellent dining-room service. Shown is the steamer *Mount Desert* in the 1920s.

Three
THE MID-COAST

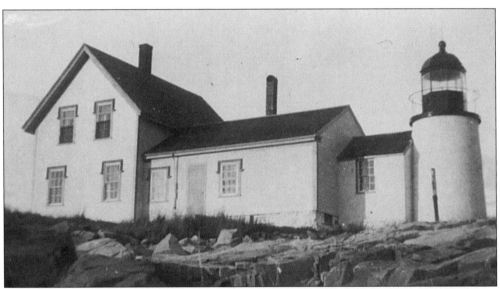

East of the Penobscot lie Mount Desert Island, Frenchman's Bay, and the mid-coast region of Maine. The shores along this region are more bold than farther south, if that is possible. Along this section of coastline, perpendicular cliffs and precipices are backed by towering hills, creating a truly magnificent sight. In examining the islands here, the smaller ones seem to have been allotted to Casco Bay, while this area claims many of the larger ones to supplement its rugged coastline.

Winter Harbor Light lies on the southern point of Mark Island, marking the approach into Frenchman's Bay. The light here was first established in 1856 when shipping in the area was flourishing. Winter Harbor Light, or "Mark Island Light," answered the needs for the area for 77 years until it was sold in 1934 to the highest bidder. One of the residents of the station in later years was author Bernice Richmond. Included in her many literary works are *Our Island Lighthouse* and *Winter Harbor*. Both are wonderful reminiscences of her experiences living at the light.

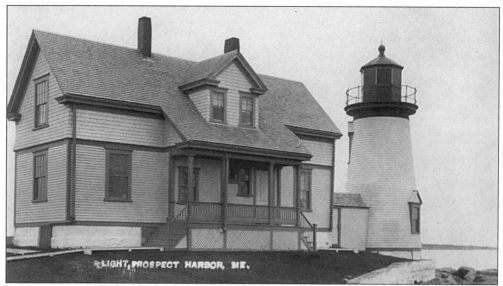

Prospect Harbor Light is a pretty little station marking the entrance to Prospect Harbor. The light is typical of many of Maine's smaller lights and consists of a short, white granite tower with an attached dwelling. The light is of the fifth order, flashing alternately red and white. For many years, Capt. Albion Faulkinham was the keeper. He retired only until few years before reaching the Lighthouse Service's mandatory retirement age of 70. (Winslow Co. view, c. 1914.)

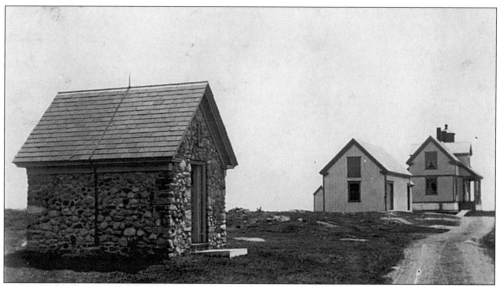

A common feature at light stations are the charming brick buildings used for the storage of the lamp oil. In the 1870s, the Light-House Establishment began a program to remove the flammable oil storage from the light towers and construct oil houses at each station. The buildings were quite attractive and generally made of red brick with pitched slate roofs. Shown is the oil house at Prospect Harbor; it is quite unusual with its fieldstone construction. (Winslow Co. view, c. 1912.)

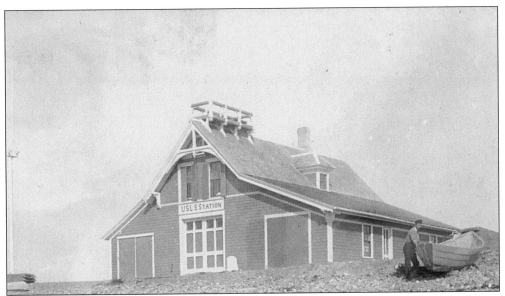

Cranberry Island's Life-Saving station was located on Little Cranberry Island, just off Mount Desert Island. The station was built in 1878 and expanded on each side. In 1912, the lookout deck was replaced with a four-story tower in the front and a roof dormer on one side. Crews here took turns keeping watch during daylight hours from the tower. At night and during storms, beach patrols were dispatched to patrol the shore for signs of a wreck. This photo is a c. 1912 view.

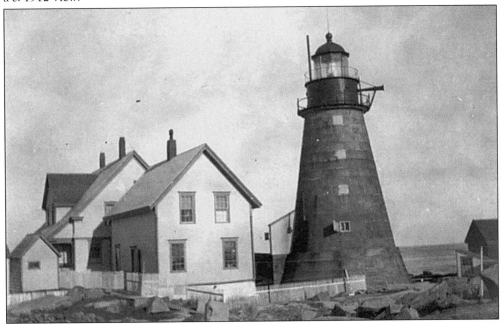

Mount Desert Rock Light is the outermost beacon on the Maine coast. Located some 26 miles from the mainland, the 200-by-600-yard rock is a mere speck in the wide Atlantic. The island was named by explorer Samuel de Champlain when he visited the area in 1604. The low-lying Mount Desert Rock is one of the loneliest stations in all of New England as the keepers endure the seas breaking across the rock.

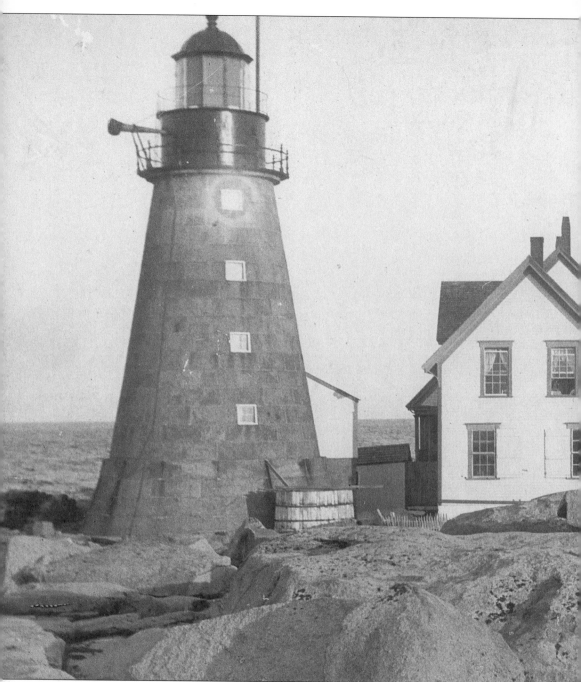

It was during the year 1830 that the first beacon was erected here. The beacon merely consisted of a lantern resting upon timbers placed on the roof of the keeper's dwelling. By the 1850s, officials of the newly formed Light-House Board recognized the need for a more substantial station at Mount Desert and, by 1857, the new structure was completed. The substantial new tower, constructed of the finest granite, measured 58 feet in height and had a broad, sturdy base that gently sloped toward the lantern in an effort to ensure its stability in heavy seas. To ensure visibility, a powerful new Fresnel lens of the third order was installed, along with a

1,000-pound fog bell mounted in a 45-foot tower. As gale-driven seas swept across the rock, the sound of the bell was not loud enough to be heard above the roar; in 1893, a new air-operated diaphragm horn was installed, its large trumpets directing the sound seaward. At the same time, the cut-granite tower was raised an additional 20 feet. Keepers at Mount Desert Rock changed frequently over the years as boredom, politics, or negligence took their toll. Some years later, as telephones and radio found their way into the service, the long evenings became somewhat more bearable.

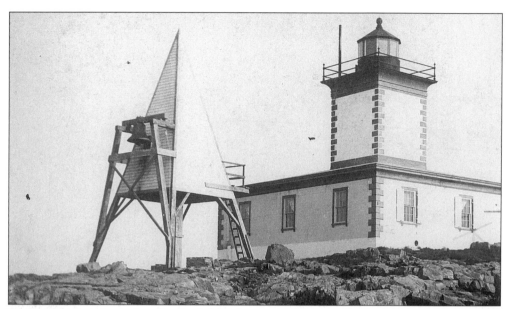

Egg Rock Light is located on Egg Rock Island, just east of Mount Desert (pronounced "dessert") Island. The unusual, square white tower, built in 1875, rises from the center of the keeper's dwelling. Egg Rock Light is one of the very few of this design ever constructed. It presents a most interesting view of Mount Cadillac as it marks the entrance to Frenchman Bay.

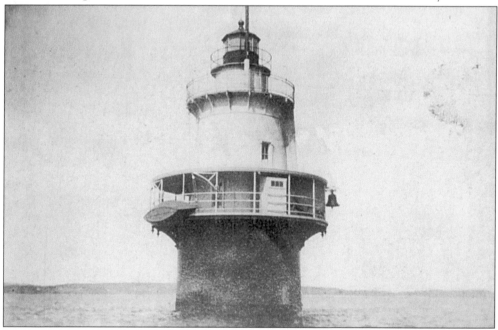

In the 1890s, as many fleets of pleasure craft plied the waters in this area, Crabtree Ledge Light Station was erected in the northern part of Frenchman's Bay to mark the dangerous ledges here. The light consisted of a brown conical tower resting on a black caisson foundation. In the 1930s, as part of the government's Depression-era economic cutbacks, the light was discontinued and sold to a writer for the *Washington Star* newspaper. (Crawfordsville view, *c.* 1924.)

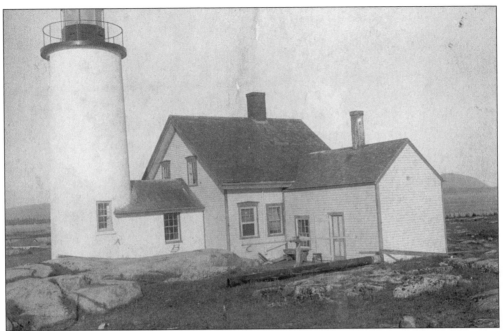

Baker Island lies off Mount Desert Island, south of the entrance to Frenchman's Bay, and enjoys one of the most spectacular views of Acadia National Park to be had. Numerous shoals and sand bars run through the area, and by 1828, Pres. John Quincy Adams ordered that a lighthouse be constructed here. The pristine white tower rises 105 feet from the water and provides a superb view. In 1878, a life-saving station was established nearby at Cranberry Island.

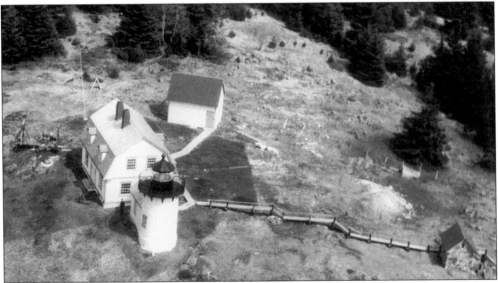

Bear Island Light Station is situated at the entrance into Northeast Harbor, overlooking Frenchman's Bay. For many years, a Lighthouse Service buoy depot and coaling station was located here, providing employment for several workers repairing and cleaning equipment. Before the construction of the triangular wooden fog bell tower, it was the custom of the light keeper to ring a hand bell when steamers were approaching. (Official Coast Guard photo, c. 1940.)

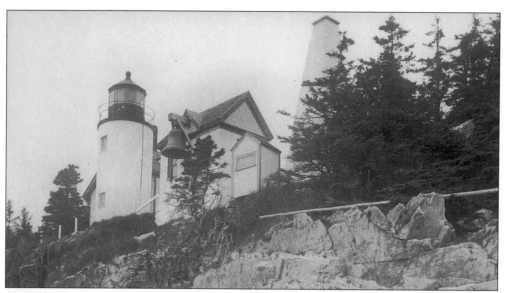

One of the most picturesque light stations on the entire coast is the Bass Harbor Head Light, which marks the east entrance over the bar into Blue Hill Bay. The light is located on a high ledge and has been the subject of thousands of photographs over the years. Capt. Joseph Grey served many years as keeper here and made it a regular practice to salute the vessels as they passed the station. Unmanned since 1974, the station now serves as Coast Guard family housing.

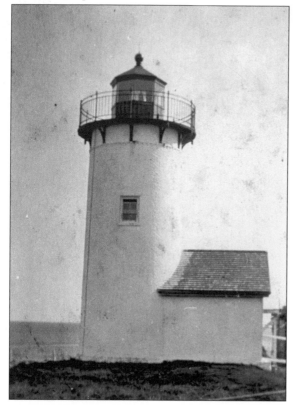

Great Duck Island, located southwest of Bakers Island, near Frenchman's Bay, was named for the thousands of Black Guillemot ducks that arrive each spring to hatch their young. The lighthouse was constructed in 1890 on one of the most difficult spots on which to land, as it faced the open sea. During World War II, telephone lines were installed to the mainland since the men stationed here would be the first to spot enemy submarines in the area.

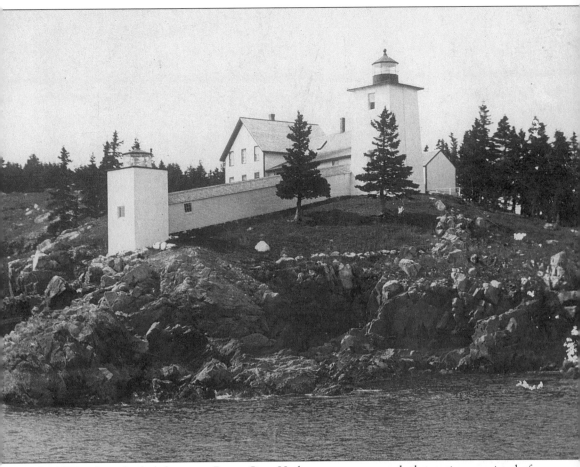

In 1872, when the lighthouse at Burnt Coat Harbor was constructed, the station consisted of two towers to be used as a range light. Following a wreck in 1885 in which the captain stated that the two lights were confusing, the smaller tower was removed and the station was converted to a single light. The station was located on Hockamock Head, on the southwest side of Swan Island, near the entrance to Burnt Coat Harbor. The fixed white light was shown from a square white tower that was connected to the dwelling to offer the keeper protection during winter storms. There was no fog signal here, but a hand bell was rung by the keeper in answer to signals. Years ago, it was a common sight to see large fleets anchoring in the picturesque cove here, as Burnt Coat Harbor has always been known as a safe refuge capable of sheltering a large number of vessels. Numerous wrecks have occurred during the treacherous winter months, with over 38 persons rescued from vessels ashore on ledges in the area.

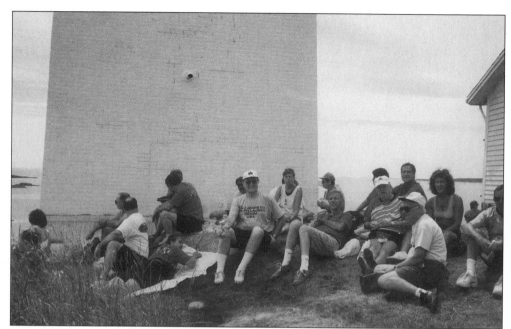

Historic light stations offer a wealth of opportunity to explore and discover the history and the beauty of the region. When you have the opportunity, do make the time to search them out and discover a bit of their history. The Massachusetts Metro-West "PWP" group, shown here taking a break from their bicycle trip, are enjoying a picnic lunch at Burnt Coat Harbor Light—a fine way to spend a day. (Photo courtesy Susan Dwyer.)

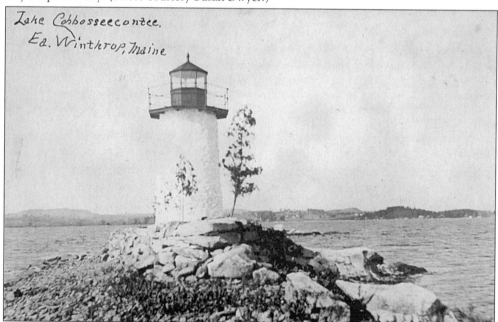

Just west of Augusta lies Cobbossecontee Lake, the home of Maine's only fresh-water lighthouse. The 9-mile-long lake is home to numerous rocks and ledges, which necessitated the construction of this small light tower in 1908. The seasonal light is maintained and operated by the local yacht club and can still be seen in the town of Manchester.

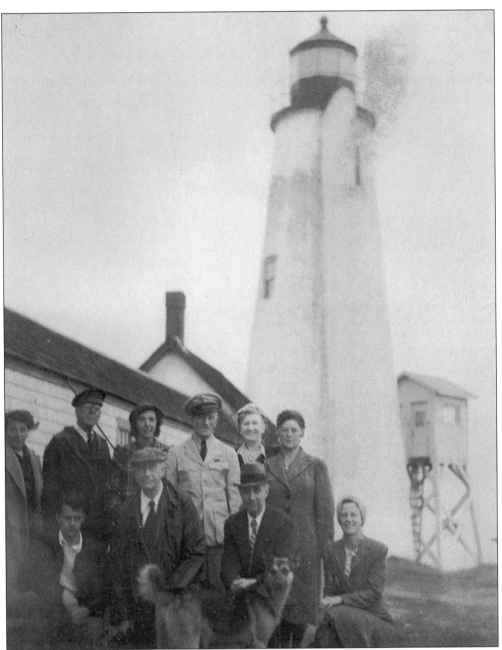

Edward Rowe Snow, author, lecturer, and historian, was born in Winthrop and spent most of his life studying the lighthouses, islands, and legends of the New England coast. Mr. Snow has been credited with over 100 books and pamphlets as well as newspaper articles, lectures, and tours of the area. With his wife Anna-Myrle, Mr. Snow made hundreds of visits to light stations throughout New England. The Snows considered the light keepers and their families to be extensions of their own family, and the feelings were mutual. Today, many consider Mr. Snow's interesting and readable accounts of life at these stations to have been the impetus that launched an increase in lighthouse interest and preservation. Shown is Mr. Snow (kneeling with fedora hat) visiting a light keeper in 1944. His wife Anna kneels to his right.

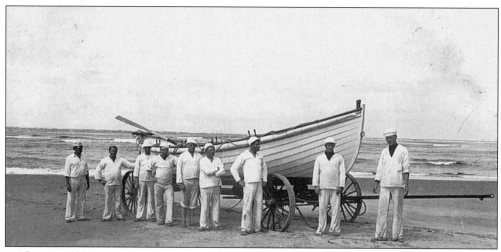

Surfboats used by life savers were designed to be smaller and lighter than the lifeboats of the day to enable the men to haul them the long distances down the rocky or sandy beaches to a wreck. Boats were manned by six surfmen with six oars and the keeper with a long steering oar at the stern. Here, the life-saving crew prepares to launch their surfboat during a drill. Note the canvas bumpers used to prevent damage when alongside a wreck.

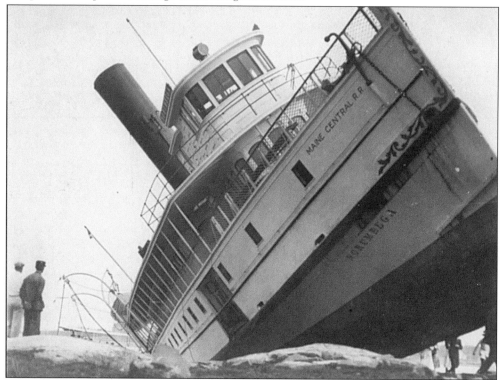

An example of the excellent service provided by the Life-Saving Service was exhibited by the crew of the Little Cranberry Station in 1883. On November 13–15 of that year, a heavy westerly gale had been blowing, causing vessels all along the coast to drag or part their moorings and be driven ashore. During this period, the Little Cranberry crew responded to no less than five vessels requiring assistance and was successful in bringing these crews to safety.

Four

PENOBSCOTT BAY

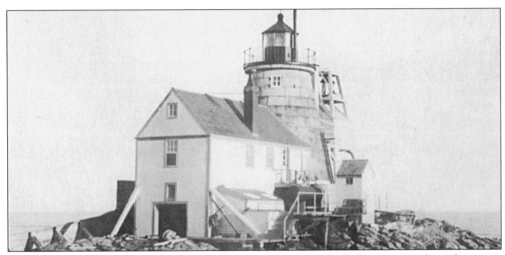

One of the loneliest stations on the Maine coast lies on a rocky ledge rising up from the ocean 3 miles southwest of Isle au Haut. Known as Saddleback Ledge, the first lighthouse was established here in 1839, shortly after 37 people lost their lives in the tragic fire aboard the *Royal Tar*. The squat, conical granite tower that was constructed on Saddleback was of superior quality. In 1855, it was fitted with a larger, fifth-order Fresnel lens. The keepers often endured great storms sweeping in across the Atlantic.

The first keeper here was Watson Hopkins, who lived with his family in the cramped four-room tower. As was common with many offshore lights, landing on the island after a trip for supplies was a most dangerous undertaking. In 1885, a derrick was installed on the edge of the rock to aid in getting in and out of the boat. It was certainly an unforgettable experience to be swung out over the rocks and deposited into the small landing boat. In 1925, Keeper Wells was overturned while trying to land and had just about given up all hope of rescue when a local lobster fisherman finally was able to pull him to safety. Winter storms often swept the ledge, and January of 1933 was no exception. Sweeping in from the south in the dead of night, the winter gale tore away 100 feet of the boat ramp and smashed portions of the breakwater protecting the base of the tower. The oil storage tank was ripped from its mountings and the boathouse door was torn away.

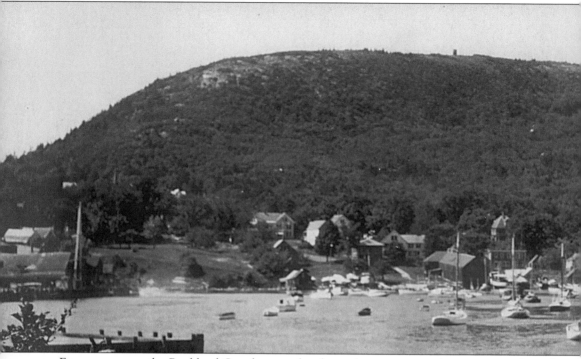

For many years, the Rockland-Camden area has been the gateway to the scenic wonders of Penobscot Bay. Swollen with the streams of half a thousand lakes and ponds, the Penobscot River widens to drain a valley 150 miles long. The Camden area is particularly lovely, and the hills and rivers of the area fairer still. Out to sea are Isle au Haut and Vinalhaven, islands of rugged beauty and invigorating air. Farther up the bay is Islesboro, the center of a group of

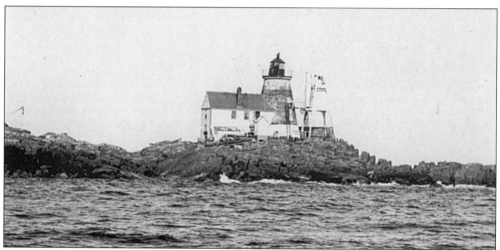

All too commonly, the bright beam from Saddleback's fifth-order lantern blinds (or somehow attracts) birds to the source with fatal results. One February night in 1927, Keeper Wells reported that while the keepers were enjoying their evening meal, "bang, bang, bang," something struck the lantern panes above. The keepers went to the tower to find hundreds of sea ducks and drakes flying headlong into the lantern glass, and by morning, over a hundred birds lay dead.

islands in the area. The mainland here grows mountainous, with Megunticook forming the apex of the Camden Hills. Farther on past Stockton, Fort Point appears, on which the British built a fort against the French and Indians. Here, too, the bay narrows to the port of Bucksport, where Fort Knox looks ominously down upon the water. (Courtesy Andy Price collection, *c.* 1910.)

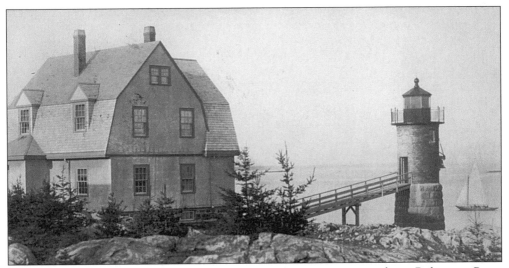

Another light guiding mariners into East Penobscott Bay rises from Robinson Point overlooking the beautiful eastern harbors. Constructed in 1907, Isle au Haut is a relatively new light station. It consists of a 16-foot granite and brick tower, connected to the island by a short wooden walkway. Shown here in 1907, the light was manned for 27 years before it was decommissioned and sold at auction. Today, the station is home to Jeff and Judy Burke, who operate a wonderful bed and breakfast.

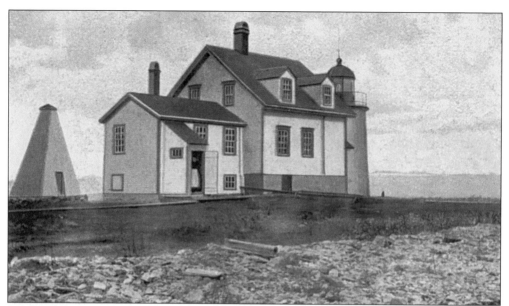

Blue Hill Bay Light, formerly Eggemoggin Light, has shown its fixed white light from the circular white tower and attached keeper's dwelling on Green Island, out over the entrance to Blue Hill Bay, since 1857. The little island consists of mostly rock and sand with little vegetation, an ideal spot for the keeper and his family during the warmer months, but most inhospitable during the winter. (Hugh C. Leighton view, c. 1910.)

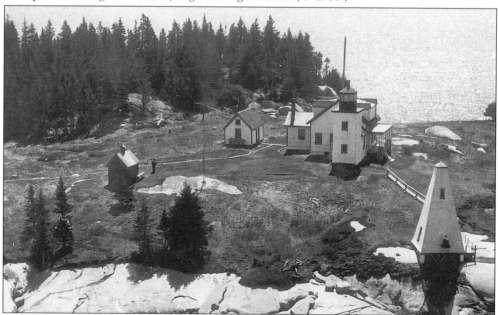

Deer Island Thoroughfare Light, or "Mark Island Light," was constructed in 1857 to mark the western entrance to the Thoroughfare for fishermen and the deep-water trade. In the 1930s, the keeper suffered a heart attack and was stranded on the island because of the ice. After the lighthouse superintendent dispatched an aircraft to survey the ice and best approaches, a buoy tender was dispatched to take the keeper away to receive medical attention. (Official Coast Guard photograph, c. 1940.)

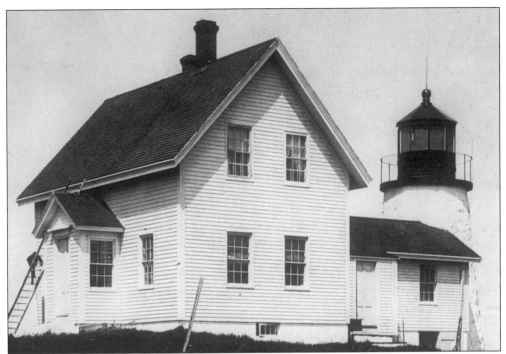

Eagle Island Light is located at the head of Isle au Haut Bay on one of the highest island bluffs in East Penobscott Bay, guiding the way toward Dice Head Light and into the Penobscot River. Eagle Island, due to its location and accommodations, was always known in the Lighthouse Service as a most desirable posting, except for the difficulties in getting on and off in heavy weather. (National Archives photograph, c. 1880. Courtesy Joe Lebherz.)

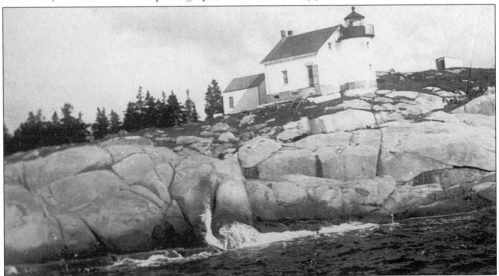

Heron Neck Light is situated on the edge of a great granite cliff on Green Island and marks the south entrance to West Penobscot Bay. In 1854, when the station was first constructed, numerous coasters ran by this station daily as they entered Carvers Harbor and Hurricane Sound. The light station consists of a white tower attached to the dwelling and makes a beautiful scene, backed by the thick wood of spruce.

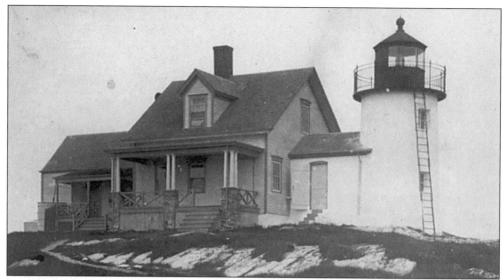

Pumpkin Island Light is located at the western entrance to Eggemoggin Reach and is one of the smaller lights of East Penobscot Bay. The station, built in 1854 during the Mexican War, has seen hundreds of cargoes of lumber and lath pass by on their way to cities in the South. Though the island is only a small outcropping, this station made a lovely home for its keeper and his family for over 80 years. (Eastern Illustrating photo, c. 1916.)

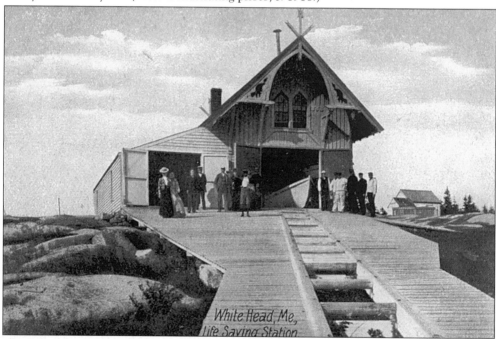

The life-saving station on Whitehead Island was first constructed in 1873–74 of a design similar to those at Quoddy Head and Cross Island. Typical of the 1874 design, the exterior was highlighted by ornate wooden brackets in the gables, diagonal boards on the side panels, and sometimes buttresses on the corners for stability. Note the tracks leading from the boat-room on which the heavy surfboat could be more easily lowered into the water. (Hugh C. Leighton view, c. 1910.)

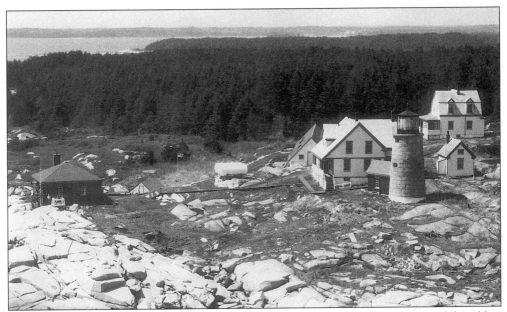

Whitehead Light Station, at the western edge of Muscle Ridge Channel, is one of the oldest stations on the coast. It was ordered to be built in 1807 by Pres. Thomas Jefferson. This location has long had the reputation of having more hours of fog each year than any other station, averaging 874 hours of fog a year. In 1837, a fog bell was erected here. It was rung by the actions of the tide and was well received by the area's mariners. (Coast Guard photo, c. 1951.)

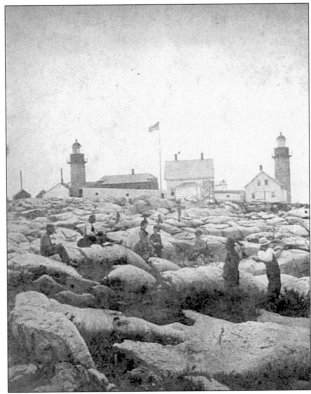

One of the loneliest outposts along all of the Maine coastline has always been the twin light towers guarding Matinicus Rock. Located 22 miles out to sea, off the southern entrance to Penobscot Bay, this barren, sea-stained island has been the home to light keepers and their families since 1827, when 65-year-old John Shaw and his wife first lit the oil lamps in the twin wooden towers here.

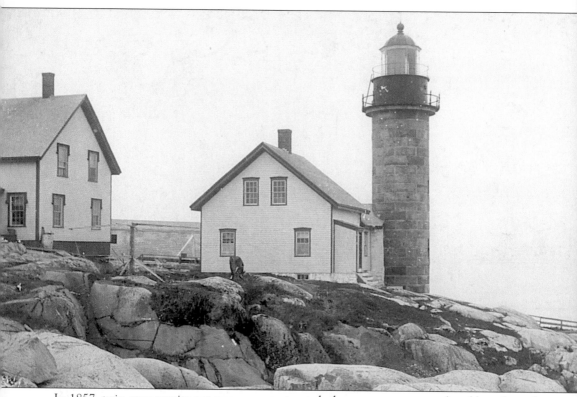

In 1857, twin gray granite towers were constructed; they are now among the oldest along the coast. During this period, Capt. Samuel Burgess moved with his family to Matinicus Rock to become one of the three keepers assigned to this station. Over the years, his 14-year-old daughter Abbie was to become a most able assistant as she accompanied her father on his rounds. Often, when Captain Burgess was ashore for supplies, the duties of keeping the light would fall to Abbie. It was in January of 1856, while her father was ashore, that a great gale swept up the coast. As the gale threatened the dwelling, the girls and their invalid mother took refuge in the light tower, remaining for days until the storm abated. Despite the storm's fury, young Abbie kept the lighthouse lamps trimmed and lit. It would be four weeks before the seas would allow Captain Burgess to return. In 1861, Captain Burgess retired, succeeded by Capt. John Grant and his family. The Burgess family would remain there a short time to instruct the Grants in the care of the station.

During this time, Abbie met and fell in love with Captain Grant's son Isaac, who she soon married. Abbie and Isaac Grant would remain on Matinicus, where Isaac would be appointed assistant keeper until 1875, when they would become keepers at Whitehead Light Station on Muscle Ridge Channel. Captain Grant can be seen standing next to the tower in this view. Seated with the rifle is his son, Bill Grant. In 1890, he would succeed his father as keeper. Also pictured is the family dog, Cap.

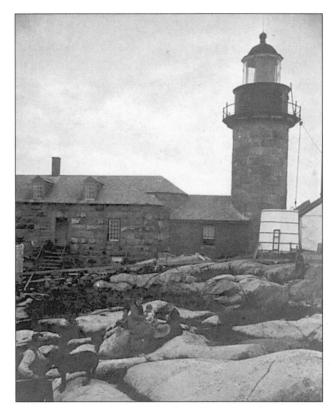

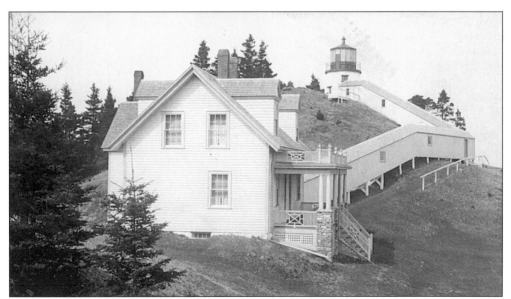

On the high, wave-beaten promontory near the entrance to Rockland Harbor is the headland known as Owl's Head. This area had been the scene of a number of American Indian battles until the 1850s, when the local native tribe was finally driven from their lands. Following a number of wrecks in the area, a stately granite tower was built here, and the first lighthouse lamp was lit in 1825. The tower is accessed by a long, winding wooden stairway.

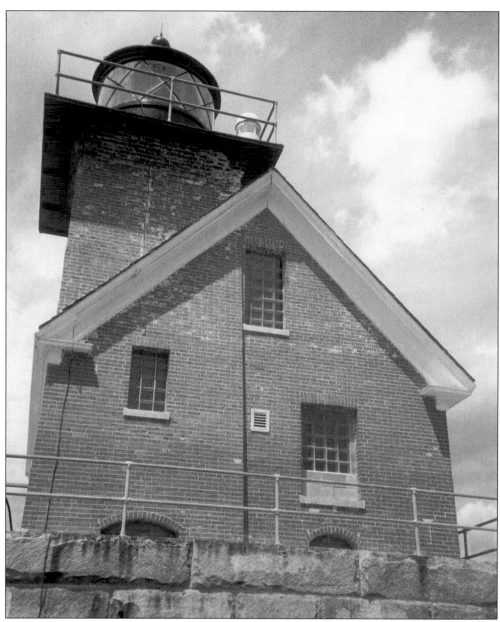

In the center of Rockland, near the old Hotel Samoset, a massive granite breakwater was constructed that extended 4,300 feet out from Jameson Point into Rockland Bay. In the 1880s, the city saw a great number of coasters passing in and out of the harbor servicing the lime industry here, and the breakwater was essential in protecting the vessels and harbor facilities. On the tip of the breakwater, the Lighthouse Service constructed, with granite and brick, a fog signal building with the attached light tower and keeper's dwelling. The tower was first fitted with two fixed red lens lanterns hung on a wooden mast. By 1902, a fourth-order, flashing white light was installed, and the station was equipped with a first-class Daboll fog trumpet. In the 1960s, the light was decommissioned and began its long process of deterioration. Today, under the sponsorship of the New England Lighthouse Foundation and together with local groups, a fund-raising and restoration effort has begun to save this beautiful old sentinel.

At the east end of the Fox Island Thoroughfare, in mid-stream, is the "sparkplug"-style Goose Rocks Light. The light was constructed in 1890, and two keepers worked and slept within its metal shell for over 70 years. Designated as a "stag" station, there was no space for the keepers' families within the light itself, so it was usually Lighthouse Service practice to provide shore housing for the families and rotate one keeper ashore for eight days each month.

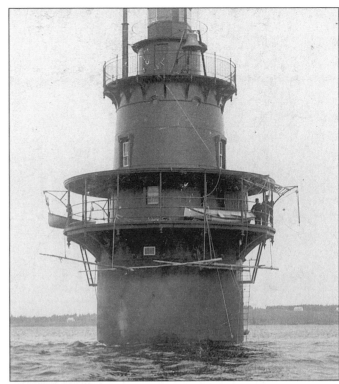

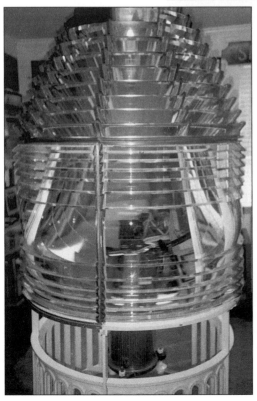

The next time you are in the Rockland area, you will surely want to include the Shore Village Museum at 104 Limerock Street on your itinerary. Here on display is one of the finest collections of lighthouse artifacts and memorabilia to be found anywhere in the country. The museum was the idea of Ken Black (USCG Ret.), who commanded light vessels and shore stations for many years. He will give you a warm welcome when you stop by.

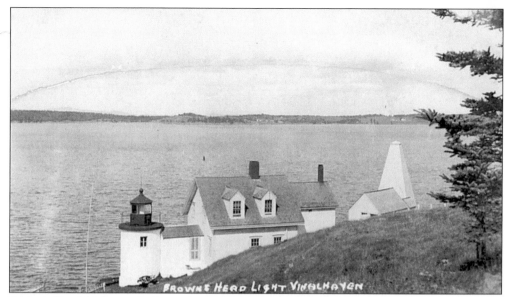

Brown's Head Light was built on the southern point of the Fox Islands some 6 miles from the village of Vinalhaven. The squat, white tower was built in the 1830s and rebuilt in 1857, serving well for over 100 years to guide mariners to the Fox Island Thoroughfare. The light tower was connected to the dwelling by a covered walkway, which allowed the keeper and his family to maintain the lamps in all types of weather.

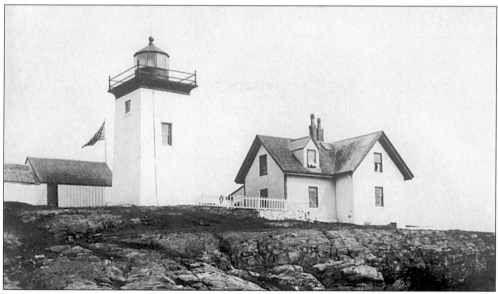

In 1849, the federal government purchased Indian Island for the sum of $25 and, in 1850, built Indian Island Lighthouse. The light was located on the southern point of the island to mark the east side of the entrance into Rockport Harbor. Later called Lovell Rock Light, the original beacon atop the keeper's quarters was rebuilt in 1874 as a square pyramidal tower and detached dwelling. In 1932, the light was decommissioned and is now privately owned.

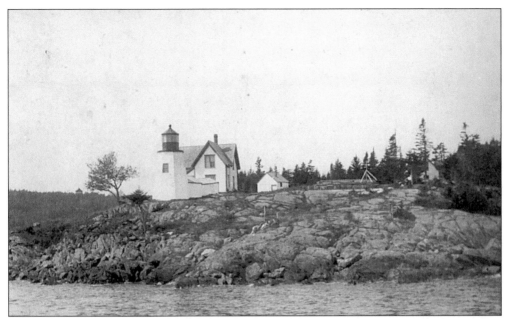

Negro Island lies on the south side of the entrance to Camden Harbor and has been marked by a light station since 1835. The spot commands an unsurpassed view of the area. In the 1920s, publisher Cyrus H.K. Curtis of the *Saturday Evening Post* was often seen sailing past in his luxury steam yacht, *Lyndonia*. In the 1930s, in gratitude to Mr. Curtis for his philanthropic work, the island was renamed Curtis Island.

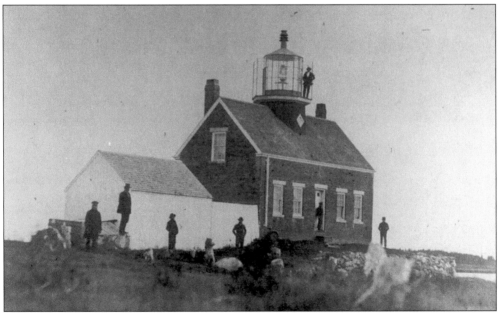

Grindel Point Light (sometimes spelled Grindle) marks the north side of the entrance to Gilkey's Harbor on the west shore of the island of Islesboro. The lighthouse here was one of the earlier lights, with the lantern room in the center of the roof of the dwelling. The light received its name from Francis Grindle, the owner of the land on which it is located. Mr. Grindel was later made keeper here in 1853. (Photo courtesy Shore Village Museum.)

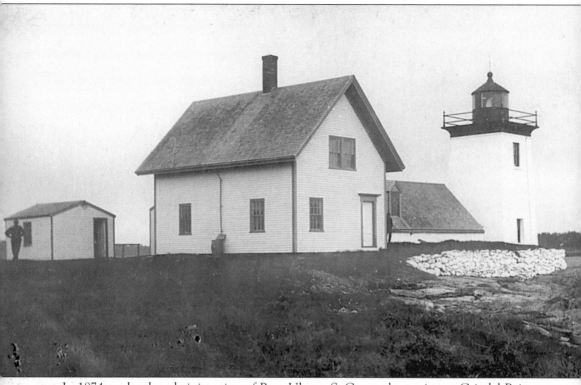

In 1874, under the administration of Pres. Ulysses S. Grant, the station at Grindel Point was rebuilt and exhibited a fifth-order, fixed white light. The tower was similar to many built at the time, being square, 33 feet in height, of brick construction, and connected to the keeper's dwelling by a covered walkway. In 1916, James E. Hall was the keeper here. Keeper Hall was later killed while blasting to clear land near the station. In 1934, the light was unmanned and faced either being demolished or sold at auction. The residents of Islesboro soon banded together to purchase the property, and today, the lighthouse and dwelling are beautifully maintained as a museum and monument to the island's seafarers. Access to the island is only a short excursion by ferry from Lincolnville Beach and makes a wonderful day trip.

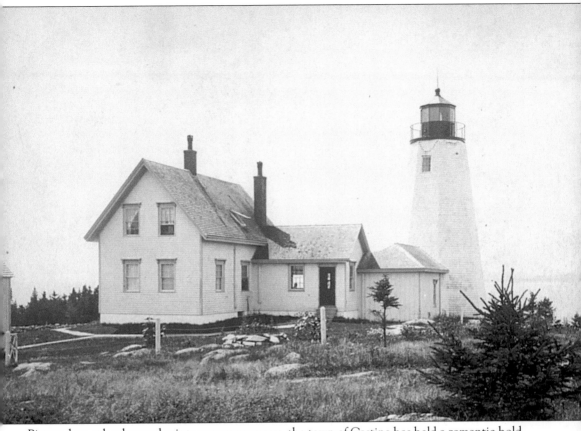

Pictured on calendars and prints over many years, the town of Castine has held a romantic hold on visitors young and old. On the north side of the entrance to Castine Harbor, guarding the mouth of the Penobscot River, lies Dice Head Light Station. The town of Castine was initially settled as a trading post and was later lost to the British during the American Revolution. In 1828, the first light here was constructed, consisting of a 40-foot rubble stone tower. Soon moisture began to eat away at the structure, and by 1857, the walls had deteriorated to the point that a new brick-lined tower had to be built. The exterior was encased in an octagonal wooden shell to further protect against moisture, but it was removed in 1900. In 1935, the light was deactivated and the keeper's position discontinued, replaced by an automated skeleton tower at the water's edge. Though the tower still exists today, the dwelling was heavily damaged by a fire in 1999. It remains uncertain as to whether it will be repaired.

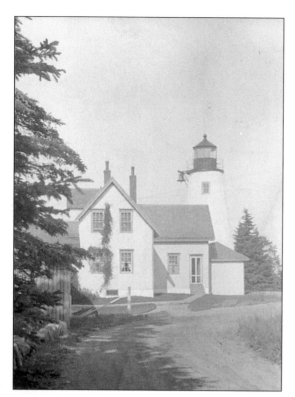

In 1929, Bill Wincapaw was piloting his floatplane toward Rockland when he became lost in a northeaster. Caught in a white-out, he flew lower and lower until he spotted the beam of Dice Head Light and was then able to find his way home. That Christmas, he loaded his plane with gifts and retraced his route, dropping gifts at Dice Head Light in thanks to the keeper who had saved his life. Author Edward Rowe Snow would continue that tradition for many years.

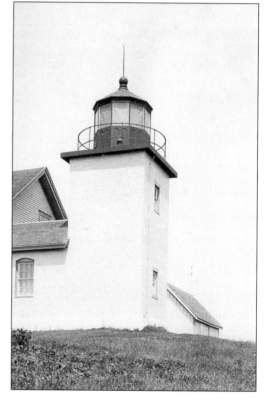

Five miles down the bay from Dice Head Light, as you begin to sail up the Penobscott River toward Stockton Springs, you pass by a point of land known as Fort Point. In 1836, President Jackson ordered that a light station be constructed here, one of the first river lights to be built in the area. Fort Point Light was a most comfortable station and, generally, one of the finest kept on the coast. (Eastern Illustrating photo, c. 1918.)

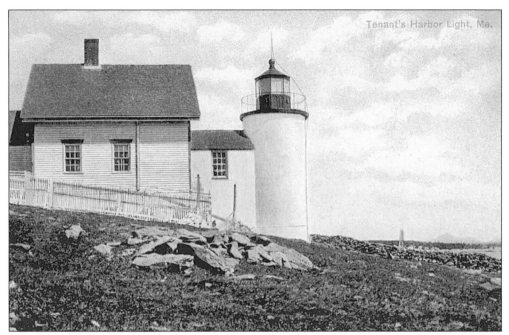

Southern Island is a handsome little island guarding the entrance to Tennant's Harbor. The cylindrical, white brick light tower was built in 1857 and served the area for nearly 80 years until closing in 1933. Today, the station is lovingly maintained as a home and studio by renowned artist Jamie Wyeth, who keeps the station in pristine condition. The cozy harbor here also makes a fine overnight anchorage for local boaters. (Metropolitan view, *c.* 1910.)

Two Bush Island Light lies on a barren outcropping marking the entrance to Two Bush Channel, off Sprucehead Island. The 65-foot tower here was constructed in 1897 and employed a keeper until the 1960s, when the station was automated. In the 1930s, due to its isolation, the keeper's school-age children were boarded on the mainland during school sessions, returning for holidays and vacations. (G.W. Morris view, *c.* 1906.)

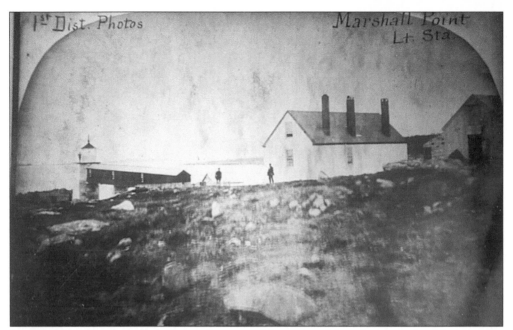

Marshall Point Light stands at the southern tip of the peninsula, on the east side of the entrance to Herring Gut, or St. George's Harbor, and marks the entrance to Port Clyde. During the presidency of Andrew "Stonewall" Jackson, a lighthouse here was authorized and a 30-foot rubble stone tower, painted white, was completed in 1832. The cast-iron lantern was originally fitted with seven oil lamps, each backed with 14-inch reflectors. (Courtesy Marshall Point Lighthouse Museum.)

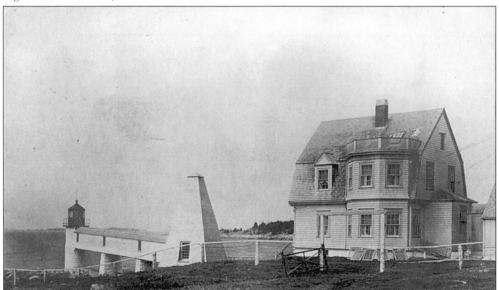

By the 1850s, the light tower had begun to deteriorate due to faulty mortar, and, by 1857, a new cylindrical tower was completed. The base of the tower was made of granite, topped with brick and connected to shore by a covered walkway. In 1895, the keeper's house was struck by lightning and damaged in the resulting fire, and the present colonial style residence was built the next year. The granite oil house was added in 1905. (Eastern Illustrating view, c. 1910.)

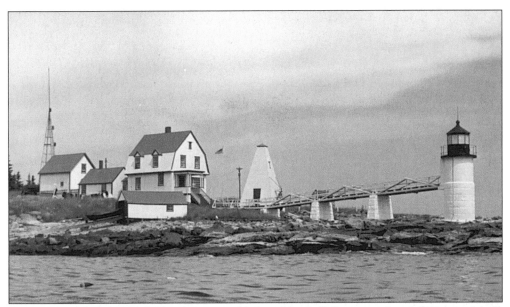

In 1898, an obelisk-type bell tower was added at Marshall Point, with a 1,000-pound bell. The U.S. Weather Bureau also maintained a station here and displayed storm warnings on the tall steel tower. In 1971, the station was automated and in 1980, the dwelling boarded up and abandoned. By 1988, the Marshall Point Restoration Committee obtained funds to restore the keeper's residence. Today, the house hosts a wonderful lighthouse museum. (Joel Miller view, c. 1948.)

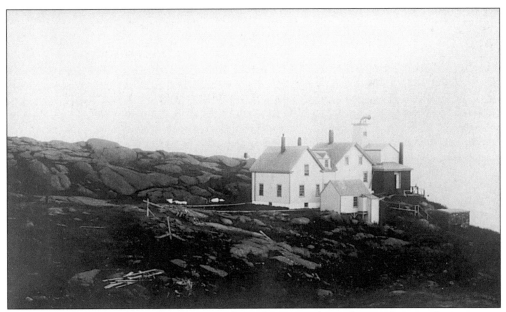

Because of the many days of intense fog along this area of coastline, a fog signal station was constructed on Manana Island, off Monhegan Island, in 1870. The station was located on the west side of the island, hidden from Monhegan but in an ideal spot to project its signal out to sea. During periods when the trumpet or steam boiler were inoperative, the keeper would be required to strike the station's fog bell by hand, sometimes for hours.

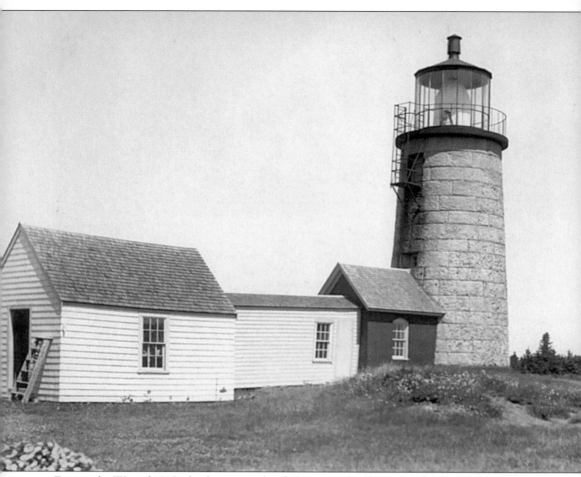

During the War of 1812, the famous sea battle between the *Boxer* and the *Enterprise* was fought off Monhegan Island, ending in an American victory while the residents watched from their rooftops. The first lighthouse here was built in 1824. A 30-foot structure built on the highest point of the island, it sent out its flash from 178 feet above the sea. Monhegan became more important as it was the first point sighted in most trans-Atlantic voyages. As sea traffic increased in the area, a new light was needed. The present tower was built in 1857, constructed of durable granite and fitted out with a second order lens of the latest design. In 1861, just before the outbreak of the Civil War, Joseph Humphrey was appointed light keeper. The following December, after losing both sons to the war, Keeper Humphrey passed away and his wife Betty was appointed as keeper in his place. Betty Humphrey served as keeper here for the next 18 years, one of a number of women lighthouse keepers who would be appointed throughout New England.

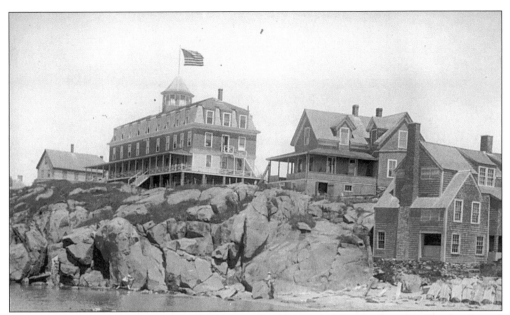

As mile-long Monhegan rises from the sea south of Pemaquid Point, the island's solitude and majestic beauty has always made it a haven for visitors as well as an ideal spot for artists, who were often seen in large numbers in the summer. In the 1800s, to house the large influx of vacationers, large, luxurious hotels were constructed across the island, some of which remain today. Traveling to the island, accessible by ferry from Port Clyde, makes a wonderful day trip.

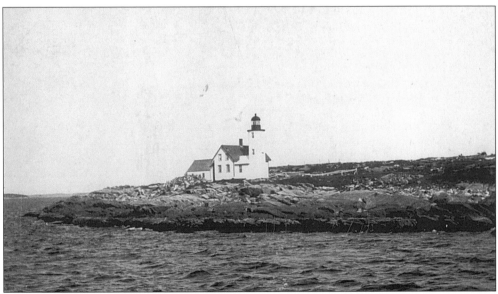

Franklin Island Light is the third oldest light station in Maine, having been constructed by order of Pres. Thomas Jefferson in 1806. Ship building in the area around Friendship and the St. George River was increasing during this period, requiring a light to guide vessels into Thomaston Harbor. Though the dwelling and buildings were not unattractive, the rocky island was a barren and isolated posting for its keepers.

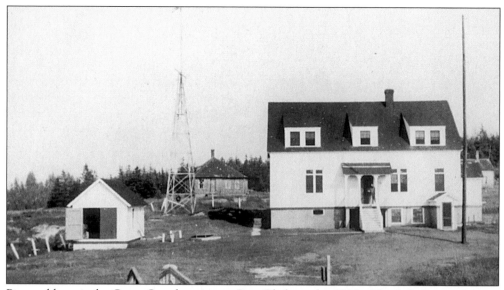

Pictured here is the Coast Guard station at Port Clyde in the 1930s. The Life-Saving Service had undergone many major changes by 1915. As a natural progression, the units of the Life-Saving Service and the Revenue Cutter (Marine) Service were combined into a new service that became the U.S. Coast Guard on January 28 of that year. In 1938, the Lighthouse Service would also become a Coast Guard responsibility. (Eastern Illustrating view, c. 1930.)

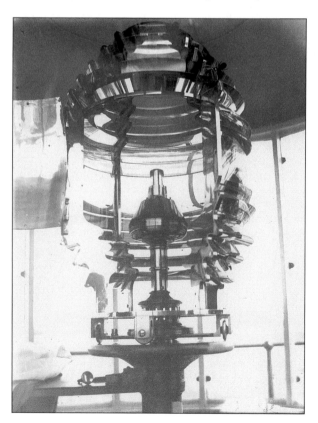

Shown is a typical fourth-order Fresnel lens used in the 1890s. Lens apparatus was classified in six orders or sizes, the first order being the largest and most powerful, standing about 12 feet tall. Note the oil burning lamp in the lens center. Lighthouse lamps had one or more circular wicks for more efficient burning and were manufactured of brass at the Light-House Depot on Staten Island, New York. (Courtesy Vincent L. Wood collection.)

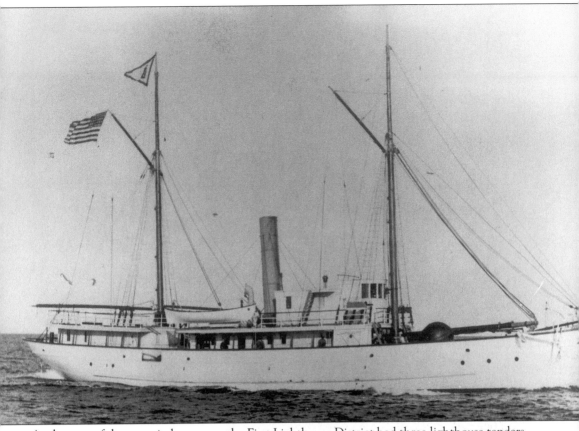

At the turn of the twentieth century, the First Lighthouse District had three lighthouse tenders in service; the *Lilac*, the *Geranium*, and the *Myrtle*. A typical tender of this era was a steel screw steamer, coal-burning side-wheeled, with a walking beam engine. Tenders were used to deliver fuel and supplies to lighthouses and light vessels within the district and to repair buoys and navigational aids. As an example, in 1891, the *Lilac* was employed for over 200 days during which it repaired or painted 733 buoys, delivered 173 tons of coal and numerous loads of rations and supplies, and steamed 15,298 miles. Another duty of the tender was to transport the district lighthouse inspector to each station for his periodic inspection. When the inspector was aboard, the tender would fly the inspector's white triangular pennant, which would alert the keeper that the inspector was on board. Keepers and families would always watch for this pennant, for it meant that all must be in order and polished to perfection. Shown is the Lighthouse tender *Azalea*, c. 1891. (U.S. Coast Guard photo courtesy Shore Village Museum.)

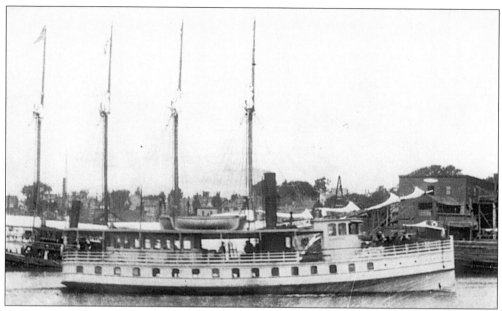

On June 8, 1935, while steaming in dense fog up the Penobscot, the steamer *Castine* came hard aground on the ledge. Though Captain Coombs was running at dead slow, the *Castine* had struck hard and soon lurched over to a 45-degree angle. Scores of passengers were thrown into the water. The crew and area fishermen made every effort to rescue those in the water, saving all but four passengers, but the vessel would prove a total loss. (Eastern Illustrating view, *c.* 1930.)

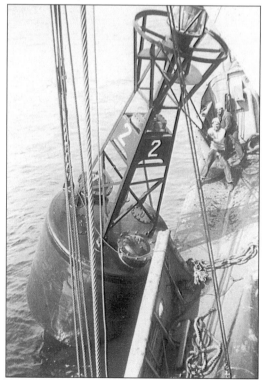

Today, tenders of the U.S. Coast Guard still brave the weather to maintain the thousands of buoys, lighthouses, and other aids to navigation as their predecessors did over a hundred years ago. Shown are the crew of the Coast Guard buoy tender *Hibiscus* in 1944 laying a 14-ton buoy on station. Note that this was in the days before hard hats and life jackets were mandatory for such work. (Courtesy Raymond Herberger collection.)

Five

CASCO BAY

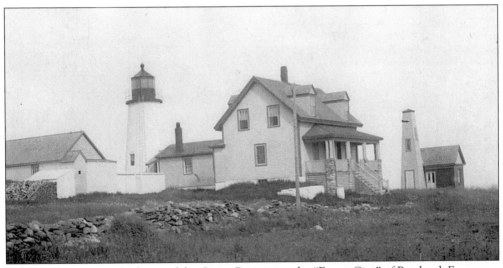

The central figure in the heart of the Casco Bay area is the "Forest City" of Portland. For over a century, this area was well equipped with luxurious hotels and boarding places to greet the Victorian traveler. The area was well connected by rail and by steamship to all of New England and the Provinces. For years, Portland was the hub for the great Eastern Steamship Company, providing inexpensive travel linking Boston with St. John and points in between.

At the tip of the Pemaquid peninsula, on the southwest entrance to Muscongus Bay, sits one of the most photographed lighthouses along the East Coast. During winter storms, furious seas lash the rocks, sending towering waves plummeting toward the shore. The first light here was erected in 1827 and served to guide mariners heading from all directions into a safe harbor. As was the custom here, many keepers maintained a farm to supplement their meager income, and Keeper Isaac Dunham was no exception. Appointed in 1827, Dunham constructed several barns and out buildings and maintained both the light and the farm until 1837, when he was transferred. In the 1850s, Dunham would become the keeper at Minot's Ledge Light, off Cohasset, Massachusetts. He would be the only survivor when the tower collapsed into the sea during a great gale.

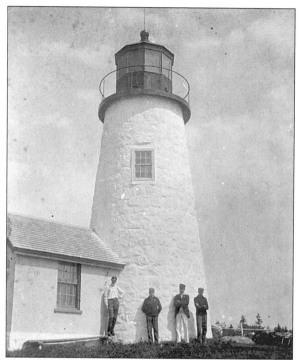

By the 1830s, the rubble stone had begun to deteriorate, and by 1835, the government contracted to have it rebuilt. In 1857, similar work was performed on the keeper's house, rebuilding it with wood rather than the original stone. Today, the two structures still stand at Pemaquid Point and are occupied by the local Fisherman's Museum. The buildings have been lovingly restored, and the area offers an unsurpassed view of the rocky coastline.

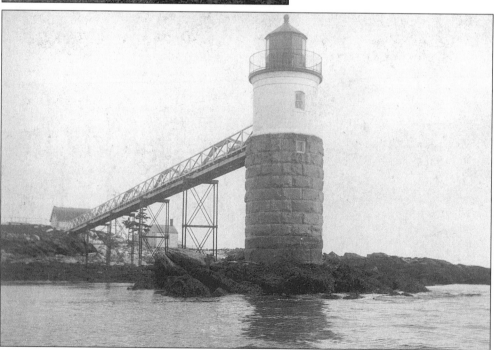

Ram Island is one of six islands near the entrance to Boothbay Harbor. For years, this area claimed numerous vessels as they attempted to make the harbor. Local fishermen on neighboring Fisherman's Island showed a lit lantern during fog or storms, but this proved of little use as wrecks became more frequent. In 1883, Pres. Chester Arthur authorized that a light be built here, and soon there was displayed a white light with red segments.

One of the newer lights along the coast lies a half mile south of Cape Newagen on a barren shoal known as the Cuckolds. With shipping increasing in the area and better navigational aids needed, a fog signal station was established here in 1892. By 1907, a light was deemed necessary and the tower was added. The station is fairly unusual with its conical-roofed keeper's dwelling and central fourth-order lantern. (Mariners Museum photo courtesy Joe Lebherz.)

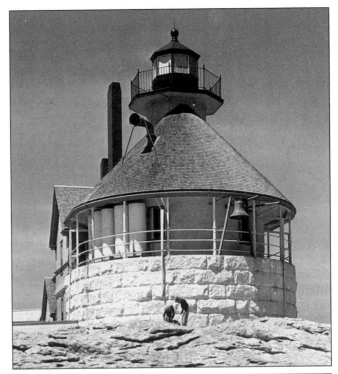

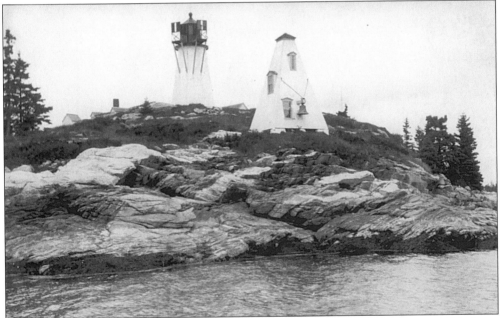

One of the older beacons on the coast is Burnt Island Light, dating back to the year 1821. Once called Townsend Harbor, this area had more vessels pass by than any other small light station on the coast. Burnt Island has always been a one-keeper station, which has required the keeper to watch the lamps for a few hours before retiring, and then check them again around midnight. On stormy nights, the keeper rarely got any rest as the light generally would require his full attention.

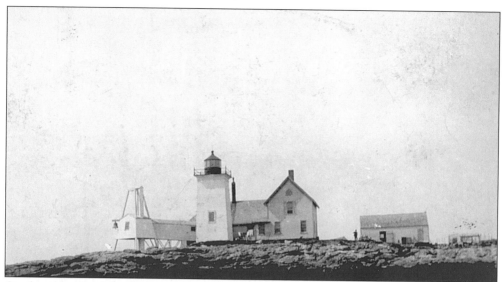

On the east side of the Sheepscot River is the light station at Hendrick's Head. In the 1870s, during a terrible blow, a vessel met its end on the offshore ledges here. As the keeper and his wife were attempting to effect a rescue, a bundle of featherbeds floated ashore. Untying the bundle, they found a wrapped infant crying without mercy. Though soon the mariners would succumb to the winter seas, the child had been saved by some unknown guardian.

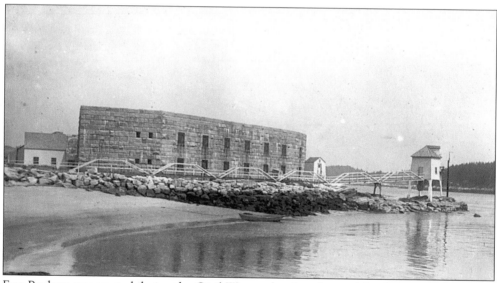

Fort Popham was erected during the Civil War at the site of one of the first English-speaking colonies in North America. The first beacon here was erected in 1899. In the 1930s, the keeper here was 25-year veteran Eugene W. Osgood. Some years earlier, while assigned to Manana Fog Signal Station, Keeper Osgood had risked his life in an effort to save a girl who had fallen from a boat. (Eastern Illustrating view, c. 1931.)

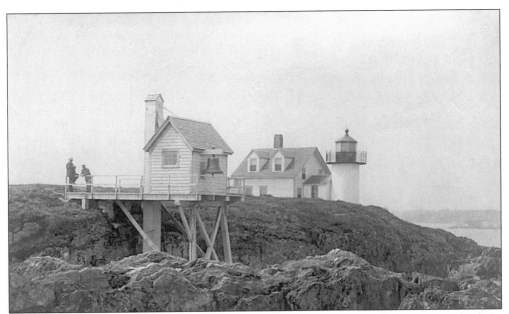

As you pass by Seguin Light and enter the Kennebec River, you will come upon the light station on barren Pond Island. The light here is a larger fifth-order and has shown a fixed white light since its construction in 1821. The short white tower is connected to the keeper's dwelling by a workroom, and south of this is the skeleton tower holding the station's fog bell. During periods of fog, the bell is struck by a weight-driven striker.

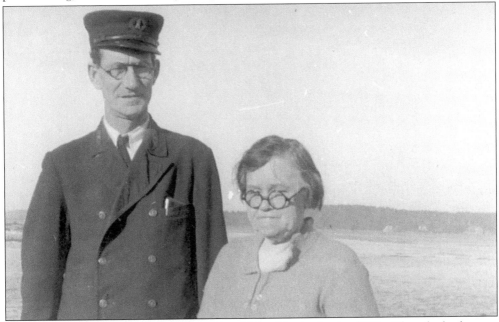

Napoleon B. Fickett was the keeper at Pond Island Light in the 1930s. Though the keepers generally loved living at these isolated stations, their wives many times suffered from the isolation. Once a week, the keeper was able to make the trip to town for supplies and catch up on news of the area. However, Lighthouse Service rules required that no keeper leave his station unattended; many times the wife was left to care for the station.

One of the most picturesque rivers in America empties into the Atlantic near the city of Bath. Here, the Kennebec River has supported countless shipbuilding firms for nearly two centuries, requiring an extensive system of navigational aids. Traveling upriver from Pond Island Light, the second light that you will pass will be the octagonal tower of the Perkin's Island Light on the east side of the river. (W.H. Ballard view, c. 1930.)

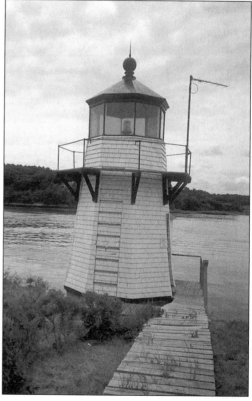

Two miles farther up the river lies Arrowsic Island, where Squirrel Point Light was constructed in 1898. Arrowsic once contained one of the largest early settlements in the area and boasted up to 50 families by the 1670s. However, Native Americans were still a threat; in 1676, a war party sneaked through the sentries, massacring nine of the families. The light was automated in 1992, and today the dwelling is a private residence.

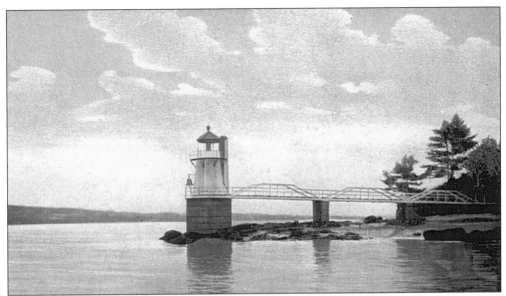

As you wind up river past Ram Island, the course takes a sharp bend where one can bring two lights in range. Known as the Doubling Point Range Lights, these are the only set of range beacons still in the First District. One keeper here was Capt. "Skipper" Henry Nye. In 1928, Keeper Nye was commended for his rescue of four persons stranded on a large block of ice as they floated down the river. (Hugh C. Leighton view, c. 1920.)

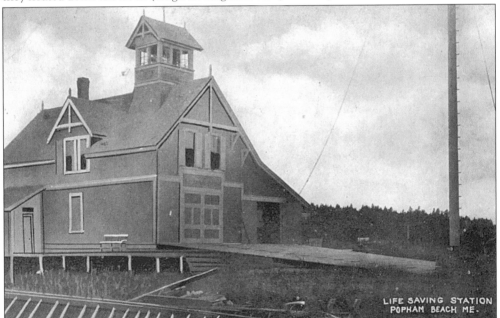

Shipbuilding in 1870s Bath caused an increase in shipping on the Kennebec River, and with it came the need for a life-saving station at Popham Beach. Called the Hunniwells Beach Station, it guarded the areas surrounding the mouth of the river. The station was similar to other 1882-type stations, except that the watch tower was enclosed to better protect the surfmen on watch. Today, the Hunniwells Beach station has been restored to its 1883 splendor as a bed and breakfast inn.

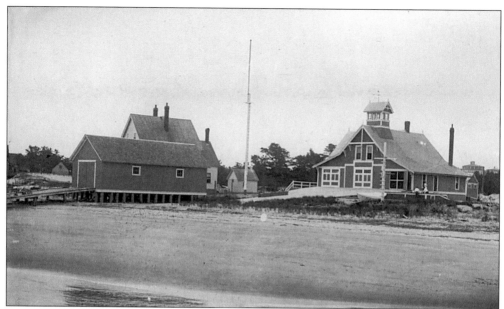

On December 12, 1898, the American schooner *Sheffeyld* struck on Pond Island during a thick snowstorm and was leaking badly. Seen by the crew of the Hunniwells Beach Life-Saving station, the crew at once launched their surfboat and pulled toward the wreck. There were 14 in her crew as 10 were taken into the surfboat and the rest put into the schooner's dory. The surfboat took the dory in tow and the crew were safely landed. (Eastern Illustrating view, *c.* 1910.)

On January 18, 1915, the Life-Saving Service merged with the Revenue Cutter Service to become the U.S. Coast Guard. Soon after, additional stations were built in Maine, and by 1941, all ten of the Maine stations were still in use. Today, all of the early stations have been closed except Cape Elizabeth. Shown is the Hunniwells Beach station, *c.* 1930, after conversion by the Coast Guard. (W.H. Ballard photo.)

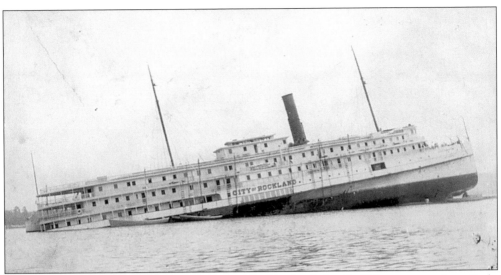

On September 2, 1923, the steamship *City of Rockland* sailed with 300 passengers from Bath. Sailing in dense fog, she soon ran aground on Dix's Island. Blasts from the ship's whistle alerted the crew of the Popham Beach Coast Guard Station, who responded immediately in their surfboat. Men, women, and children jumped into the Coast Guard boat or into the vessel's lifeboats and were soon on the beach. Some time later, the steamship was re-floated and salvaged for her fittings.

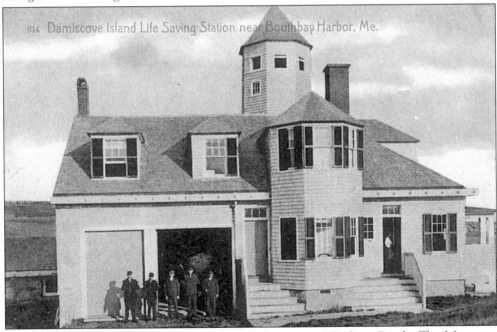

Damiscove Island is located near Boothbay Harbor, east of Popham Beach. The life-saving station here was erected in 1897. From its lookout, surfmen could see as far as Monhegan and the mainland. The station was considered to be the grandest in the first district, and from the outside it resembled the summer homes down east. In 1959, the U.S. Coast Guard ceased operations here, and like so many, the station remains abandoned and decaying. (Hugh C. Leighton view, *c.* 1910.)

The loftiest beacon in all of Maine lies off Cape Small on rocky Seguin Island, 2 miles south of the Kennebec River. In 1795, the first wooden lighthouse was constructed here and Revolutionary War hero Maj. John Polersky appointed its first keeper. In spite of the heavily wooded slopes and plentiful game on the island, life in the early years was a harsh existence. Seguin Island lies exposed to the open sea as storm after storm sweeps across the area, smashing all in its path as the elements exact their toll. A new lantern was installed in the tower in 1817,

but the wooden tower had deteriorated so badly that in 1819, a new stone tower had to be built. By the 1850s, a still larger tower was needed, and in 1857, Congress authorized the present 53-foot granite tower at a cost of $35,000. For years, the fog signal was in operation one seventh of the year, a fact that must have worn heavily on the families stationed there. (Courtesy Andy Price collection.)

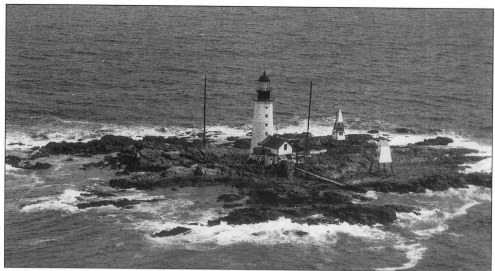

Halfway between Cape Small and Cape Elizabeth lies submerged Halfway Rock ledge. During storms, the sea sweeps across the thin rock outcropping, making it a most inhospitable site. So that it could withstand the pounding of the sea, huge granite blocks were employed during construction in 1869, to protect the base of the tower as it rises 76 feet above the water. The light first illuminated the sea lanes in August of 1871. (U.S. Coast Guard photo, c. 1940.)

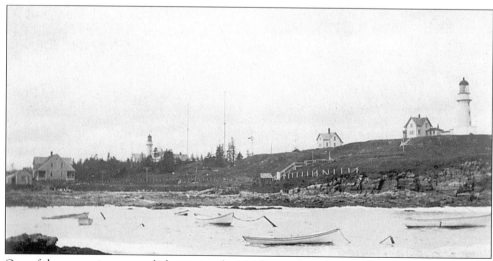

One of the more picturesque light stations lay southeast of Portland on Cape Elizabeth. In 1828, 12 acres of land were purchased for the construction of the two twin rubble stone towers here. In the early 1800s, a means was needed to make lighthouses distinctive to mariners so that they could not be confused with other locations. Today, this is accomplished by distinctive flashes, but in the early 1800s, the technology was not available.

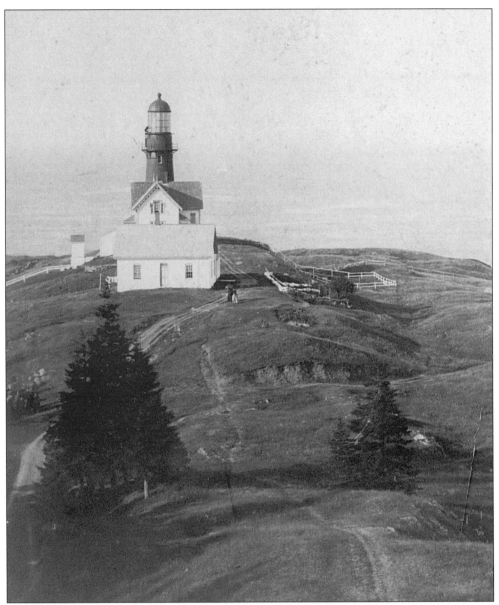

The problem of lighthouse recognition was solved by building multiple lighthouse towers. Thus, to distinguish Cape Elizabeth from Portland Head (one tower), two light towers were erected here. In addition, a new Fresnel lens was installed, and a few years later, a 10-inch steam whistle was installed as a fog signal. In 1873, the stone towers were replaced by two cast-iron towers of the latest design, and the lights changed to one fixed and one flashing. Shown is the eastern tower, as seen from the lantern room of the western tower in the 1890s. The new cast-iron towers were painted brown for ease of maintenance and the eastern tower was fitted with a fixed white first-order beacon. However, many devastating wrecks continued to occur within sight of the lights. By 1902, both towers had been repainted white for increased visibility, and incandescent oil vapor lamps installed. By the 1920s, with the advent of flashing technology, the Light-House Board determined that the two lights were no longer needed for recognition. On May 9, 1924, the west beacon was discontinued and the tower capped.

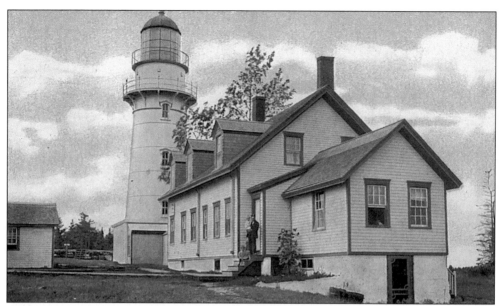

The twin beacons at Cape Elizabeth have been a landmark for over a century and are one of the few remaining twin beacons left in the country. The lovely towers and ornate keeper's dwellings here have long greeted visitors with their unique beauty and attractive architecture. Today, for want of protection, the lovely Victorian keeper's dwelling at the eastern light has been demolished to make way for a modern new construction—a piece of history now lost forever. (Leighton & Valentine view, c. 1908.)

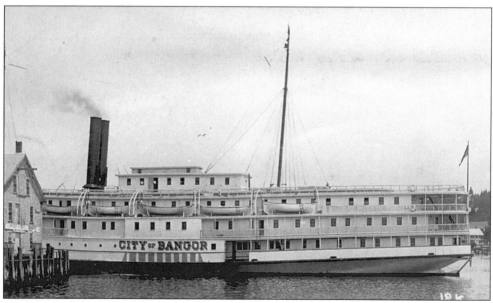

On June 8, 1906, as fog hung over the coast, Eastern Steamship Line's *City of Rockland* was making her way past Halfway Rock Light when out of the fog came her sister ship *City of Bangor*. Captain Roix swung his wheel over hard in an effort to miss the *Bangor*, but a collision was unavoidable. The *Bangor's* bow struck the *Rockland*, just aft of the giant paddle wheel, crushing five staterooms and carrying away the rails. (Eastern Illustrating view, c. 1916.)

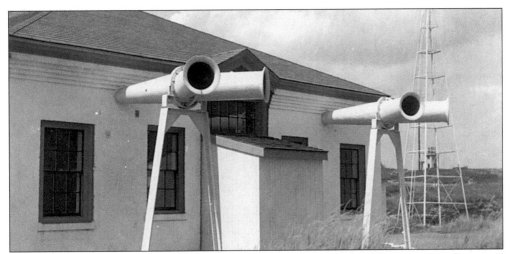

The first fog signal to warn away ships was probably at Boston Light, where a cannon borrowed from nearby Fort Strong was fired in times of heavy fog. Much experimentation was performed to perfect better signals that would carry greater distances. These trumpets at Cape Elizabeth are typical of what became the standard near the turn of the century, with various sized horns to direct the sound produced by steam-powered trumpets. (Ralph Blood view, *c.* 1930.)

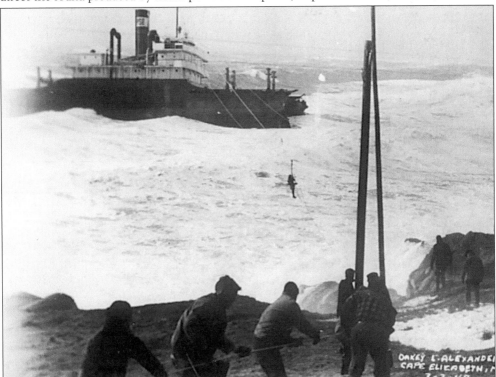

The advent of radio direction finding and other navigational aids improved safety all along the coast. However, even today there are times that nature still has her way over man's achievements. In March of 1947, the collier *Oakey L. Alexander* broke in two on the rocks off Cape Elizabeth. The U.S. Coast Guard crew was quick to respond and succeeded in rescuing the crew using the breeches buoy, one of the last times the Coast Guard would use this apparatus.

On March 5, 1820, Congress admitted Maine into the Union as the 23rd state. In 1970, to commemorate the 150th anniversary of Maine's statehood, a postage stamp was issued by the U.S. Postal Service. This attractive commemorative issue featured Edward Hopper's painting of Cape Elizabeth's east light tower and keeper's dwelling, well known as a tourist attraction and still a Maine Landmark.

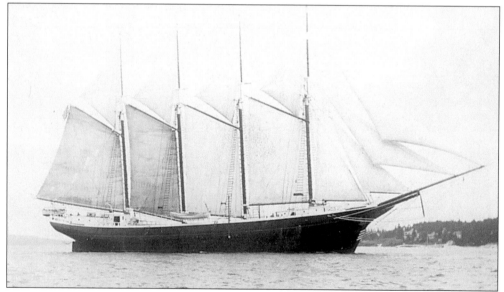

One of the most spectacular rescues in Lighthouse Service logs occurred in January 1885, during a blinding blizzard. On this night, the schooner *Australia* came ashore near the fog signal building at Cape Elizabeth. Fighting wind-driven snow and 5-foot drifts, Keeper Marcus Hanna, his wife, and the assistant keepers finally succeeded in rescuing two of the three men on board. (H.R. McGregor photo.)

Spring Point Ledge Light is located in the main channel leading into Portland Harbor. For years, ships have come to grief on the ledges running from Fort Preble into the ship channel. The white, cylindrical "sparkplug"-style tower was originally constructed in 1897, on a black caisson in 13 feet of water. It was not until 1950 that the breakwater connecting the light to the mainland was added. (U.S. Coast Guard photo, c. 1949. Courtesy Joe Lebherz.)

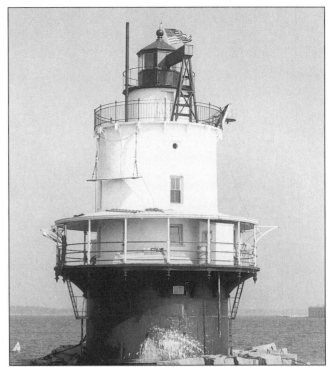

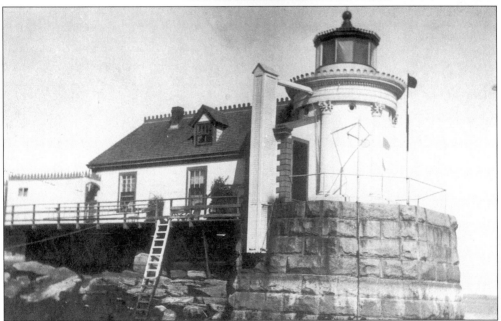

Portland Breakwater Light was constructed as a result of a devastating storm in 1831. Exposed to the full force of the sea, ships in the harbor were torn from their moorings and wharves and buildings were destroyed. In 1837, to protect against future storm swells, a 1,700-foot breakwater extending out into Portland Harbor was completed. A fixed red light here was first shown in 1855, from this unusual classic Greek 13-foot light tower. (Courtesy Andy Price collection.)

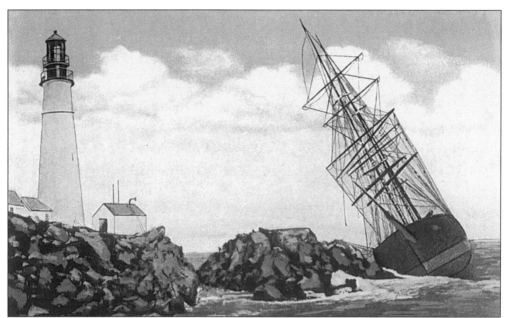

One of the most famous wrecks to occur in sight of Portland Head Light was that of the *Anna C. Maguire* on Christmas Eve in 1886. During a howling blizzard, the schooner wrecked high and dry at the base of the light. Keeper Strout worked tirelessly with his sons to rig a boatswains chair, and soon the entire ship's crew was landed safely. To this day, an inscription remains painted on the cliff wall commemorating their heroic actions. (C.T. American view, c. 1929.)

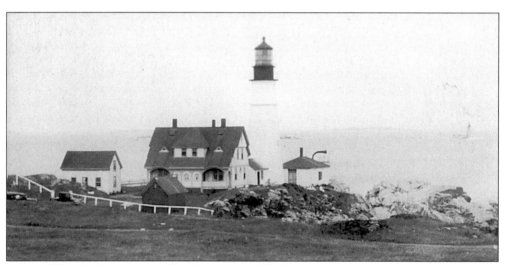

Portland Head Light, authorized by Pres. George Washington, is among the earliest lighthouses built in the United States. Construction began in 1787, and by 1790, the rubble-stone tower had reached the planned height of 58 feet. Soon the engineers found that a headland blocked the view of the light, necessitating 14 feet of additional height. This additional height reduced the top diameter and a smaller lantern was installed. It was first lit on January 10, 1791.

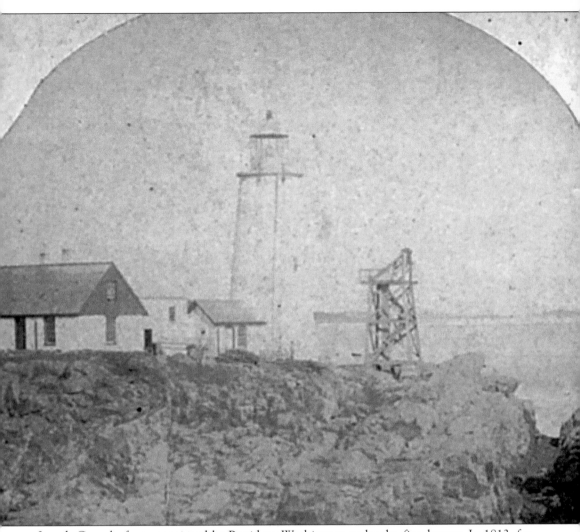

Joseph Greenleaf was appointed by President Washington to be the first keeper. In 1813, for some unknown reason, the tower was lowered 25 feet. Over the next 21 years, the tower would be raised and lowered three more times, and finally, in 1885, it was fixed at 101 feet above the sea. This exceptionally rare photo was probably taken in the late 1860s or early 1870s and shows the tower before being raised to the present height. Note also the one-story keeper's dwelling. The present two-story dwelling was not built until some years later. Portland Head Light was always considered to be one of the most desirable stations on the Maine coast, and keepers here rarely requested transfers. No family exemplified this more than the Strouts; Capt. Joshua Strout and later, his son Joseph kept the light here for close to a century. Robert Sterling, keeper here in the 1930s, notes that Joseph Strout was one of the most popular light keepers of his day, and thousands of people traveled to the station to sit and visit with Captain "Joe." (Early M.F. King view, c. 1870.)

The brown tower that has stood atop Munjoy Hill in Portland for over 190 years has often been mistaken for a lighthouse. Shortly after 1800, as commerce thrived, a means was needed to notify ship owners of arriving vessels so that dock space could be arranged. In 1807, the brown, eight-sided structure was erected in order to view the approaching vessels and, by means of flags, signal their owners. The tower remains today, a landmark that has been lovingly restored. (Adna T. Howe view, c. 1885.)

The Lighthouse Depot or Buoy Station was first established on House Island in Portland before the Civil War. When Fort Scammel was built on the site, the station was moved to Little Diamond Island where, in 1855, a wooden lighthouse was erected. Known for years as "Bug" Light, the lighthouse marked the breakwater here. In later years, the light was controlled by the keepers at Spring Point Ledge light. Shown is the headquarters depot at Staten Island, New York, c. 1900.

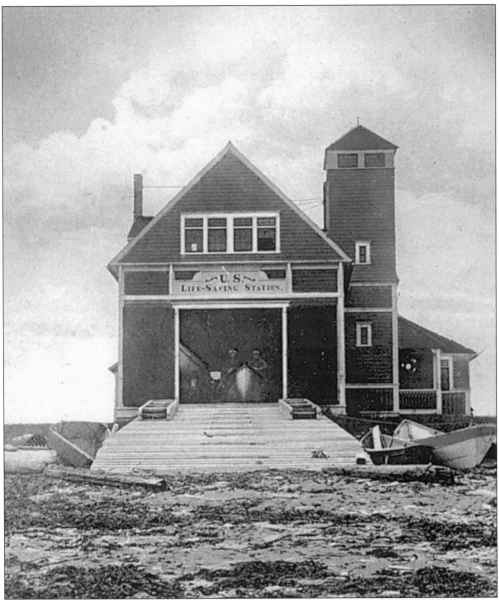

The Life-Saving Station at Cape Elizabeth was located in a cove just south of the twin lighthouses. Erected in 1887, the shingle-style design was unusual because of its green painted sides and red roof, and for the lookout tower projecting up from the side. On June 12, 1903, the crew here would face their ultimate test. It was in the evening that the *Washington B. Thomas* came to anchor 3 miles from the lightship. The next evening, with a fresh breeze and fast-rising sea, she began to drag anchor and drift toward the rocks. Despite the crews best efforts, she struck and began to break up. As heavy seas struck the vessel, the master's wife was swept away as the crew took to the rigging. The keeper at Cape Elizabeth gathered a crew and horse team, and transported the surfboat 9 miles to Prouts Neck. Thick fog, darkness, and the storm still prevailed as they approached the vessel in their boat and they succeeded in taking aboard nine of the mariners. At daybreak, they returned to the wreck to take off the remaining five men. (Hugh C. Leighton view, c. 1910.)

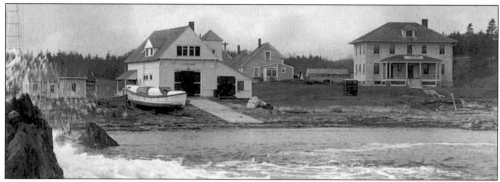

In 1915, the Life-Saving Service joined with the Revenue Cutter Service to become the U.S. Coast Guard. At that time, there were 279 stations in operation in the country. Shown is the Cape Elizabeth station, c. 1930, after conversion by the Coast Guard. Note the extra boat room added to the right side. To the left is the station's 34-foot motorized lifeboat, which would become the primary rescue craft of the service. (Ralph Blood photo, c. 1930.)

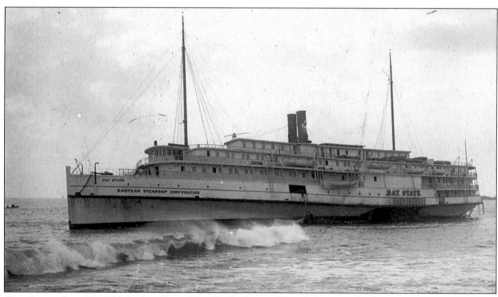

On September 23, 1916, the Cape Elizabeth Coast Guard Station lookouts were on watch in the tower. As the alert crew scanned the sea, the wooden side-wheeled steamer *Bay State* ran aground on Holycomb Reef off High Head. As the weather worsened, Captain Dyer and his crew rigged the breeches buoy apparatus and, with the aid of local fishermen, succeeded in removing all 250 passengers and crew. Over the next month the wreck would be dismantled and sold for salvage.

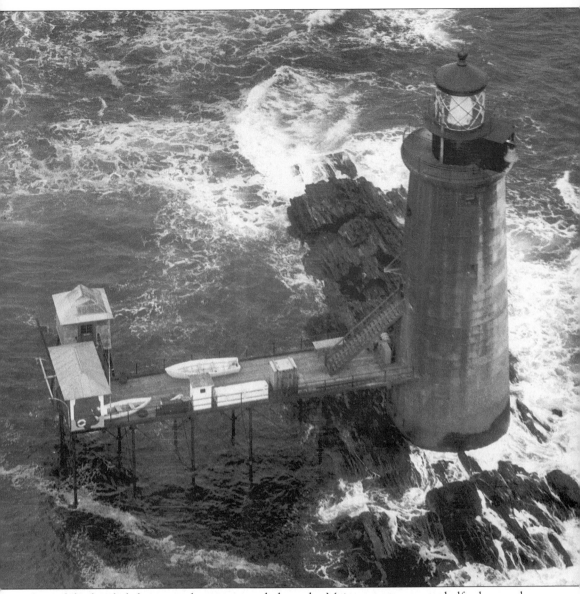

One of the last lighthouses to be constructed along the Maine coast was on a half-submerged ledge running east to west from Ram Island, in Portland harbor. For many years, sailors called for a beacon to mark the ledge, for the large gut between the ledge and Ram Island is most deceiving to the mariner. Over the years, numerous wrecks have occurred here to vessels attempting to make Portland Harbor. Among the doomed vessels running for the harbor before the light here was built was the British steamship *California*. On February 13, 1900, Capt. John France sailed his ship from Portland bound for Glasgow. A northeast snowstorm had blown up and through an error in direction, she ran ashore in the gut. The steamship's crew was saved that night, but the vessel lay on the rocks many days before being re-floated. Having a fondness for Maine and its people, and sensing the need to aid shipping here, Pres. Theodore Roosevelt instructed Congress to build a light here in 1905. The tower marks the north side of the harbor, once called Machigonne, and is a formidable structure of Maine granite. (U.S. Coast Guard photo, c. 1951.)

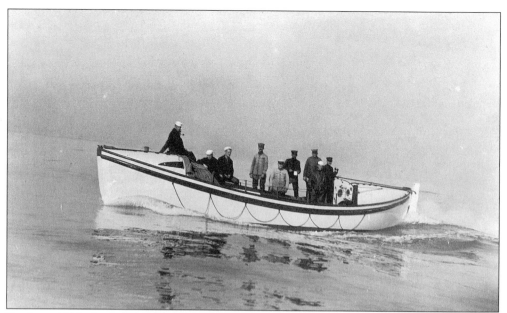

By about 1910, the Life-Saving Service began converting from pulling (oar) boats to the new motorized lifeboats. Though engines were still in their early stages of development, they afforded the life savers the ability to extend their range and to be less exhausted upon arrival. Thus, they would be better able to perform their rescue duties. Shown is a Coast Guard boat, probably a 34-foot motorized lifeboat, c. 1935.

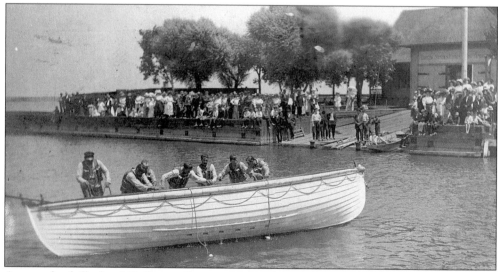

Among the drills that Life-Saving Service personnel were required to perform was the surfboat capsize drill. The ability to right a surfboat overturned by the sea was most important to the life saver's survival, and crews were required to became proficient at this procedure. Shanks and York, in their book *The U.S. Life-Saving Service*, note that the Service's record was just 13 seconds to right an overturned boat. Shown is a crew drilling in this procedure in 1912 while throngs of visitors watch.

Six

CAPE ELIZABETH
LIGHTSHIP

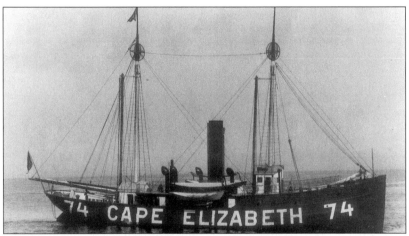

Lightships came into use in the United States in 1819 and were used to mark offshore shoals where a lighthouse could not be constructed. During the period from 1820 to 1983, as many as 116 lightship stations were established. The Cape Elizabeth lightship station was one of the more recent stations in the country. Established in 1903 about 5 miles southeast of Cape Elizabeth, it marked the approach into Portland Harbor. Vessels assigned here were moored in 150 feet of water and bore the name "Cape Elizabeth" in large white letters on a red hull. The first vessel assigned to this station was Light Vessel (LV) No. 74, built in Petersburg, Virginia, in 1902. This was the last wooden-hulled lightship built by the Lighthouse Service. The vessel was 129 feet long and was propelled with a one-cylinder reciprocating engine. She carried oil lamps at each masthead for illumination, which were replaced in 1912 by the latest in acetylene lens lanterns. On the top of the mastheads, the round, net-like objects are daytime recognition signals used to aid in being seen from a distance. Note the triangular flag flying from the mast. This flag, with a red lighthouse on a white background, was the ensign of the U.S. Lighthouse Service, as shown on page 4. (National Archives photo, courtesy Nautical Research Center.)

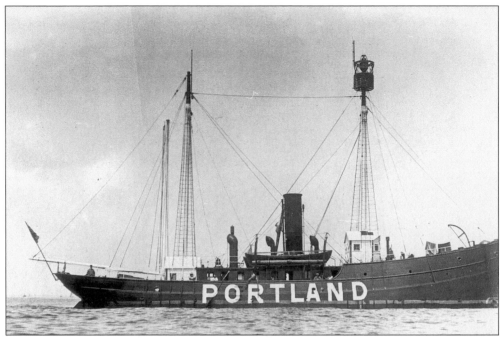

In 1912, the Cape Elizabeth station was renamed "Portland" and the vessel markings changed accordingly. In May of 1916, and again in December, the Portland LV-74 was dragged off station in a gale and unable to return for days, not an uncommon occurrence. In 1920, while docked in Portland for repairs, a fire began below deck and crews of the light vessel and the nearby Lighthouse Tender *Shrub* were finally able to extinguish the blaze. (Photo *c.* 1912, courtesy Shore Village Museum.)

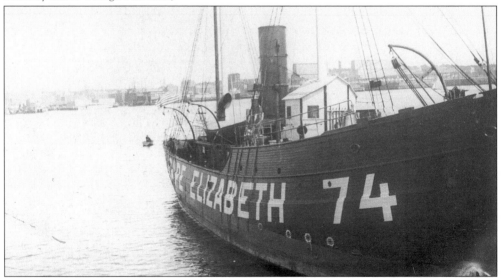

In the 1930s, Chief Engineer Edward Eaton noted in an interview with author Robert Sterling that LV-74 ". . . broke away from her moorings in the storm of February 1912 twice . . . One sea swept over the vessel from stem to stern and took everything with it" During a similar storm, they kept the 12-inch fog whistle hammering away for 24 hours. Such was the life aboard a New England light vessel. (Photo *c.* 1912, courtesy Shore Village Museum.)

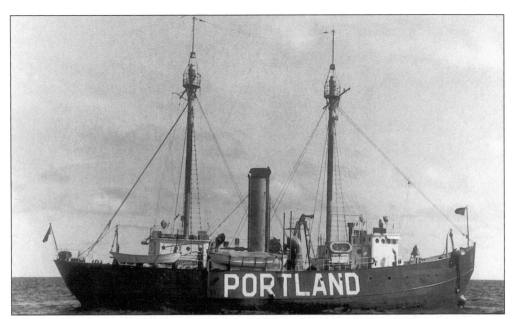

In 1931, after serving 28 years on station, LV-74 was replaced by LV-90. LV-90 was steam screw driven, steel hulled with two steel masts, had wood deckhouses, and a large smokestack amidships. Lighting was provided by a cluster of three oil burning lens lanterns raised to each masthead, later replaced with electric lens lanterns. In 1942, she was withdrawn to serve with the U.S. Navy until 1945, when she returned to the Portland Station until 1952. (National Archives photo, courtesy Nautical Research Center.)

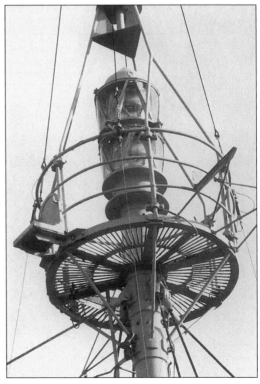

The first lamps in the 1850s consisted of a single lantern with up to eight oil burners with reflectors that were raised to the main masthead at dusk. By the 1890s, oil lens lanterns were in use, clustered three or four about each masthead. About this time, acetylene was coming into use and many lamps were converted to burn this cleaner fuel, but by 1900, most lanterns would be converted to electricity. (Courtesy Shore Village Museum.)

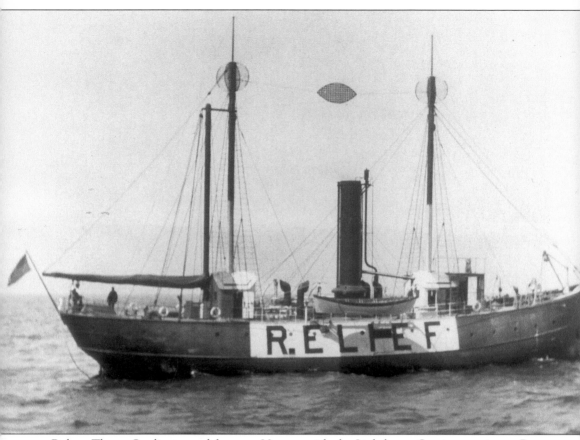

Robert Thayer Sterling served for over 30 years with the Lighthouse Service, serving at Ram Island Ledge Light, Great Duck Island Light, Seguin Light, Cape Elizabeth Light, and finally, as head keeper at Portland Head Light. In 1935, Keeper Sterling wrote a wonderful account entitled *Lighthouses of the Maine Coast*, in which he interviewed Chief Edwin Eaton of the Portland Lightship. Chief Eaton had seen many years on the vessel and commented that the ". . . lightship was a terrible roller. During a storm she would shiver and shake when the big seas struck, but she would always come out of them loon divers and again sit just as pretty on the water as a swan" Commenting in the mid-1930s, Chief Eaton added ". . . with plenty to eat and wear, a place to sleep is about all a fellow can get nowadays, ain't it?" (Courtesy Shore Village Museum.)

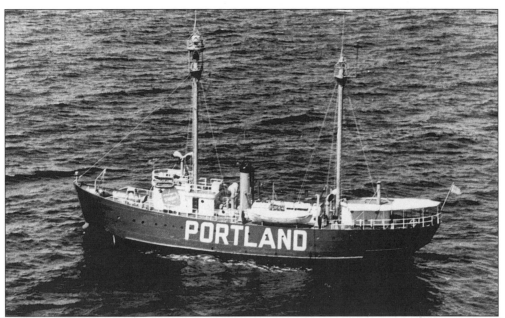

In 1952, LV-111 replaced the '90 on Portland Station, where she served until 1969. She was built in 1926 and was the first U.S. lightship built with full diesel propulsion. Construction was paid for by the Standard Oil Company, in reparation for their sinking of LV-51 on the Cornfield Point station in 1919. That year, LV-51 was rammed and sunk by a Standard Oil Company barge while under tow, sinking in eight minutes. (National Archives photo, courtesy Nautical Research Center.)

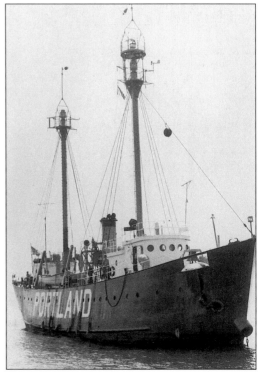

LV-114 was a diesel-electric propelled, steel hull vessel built in 1930. She was equipped with the latest safety equipment, including radio beacons, detection radar, and submarine bell. After serving at Pollock Rip station in Massachusetts, she was assigned to the Portland station from 1969 until 1971. She was built in Portland, Oregon, in August of 1930 and was the first U.S. lightship to make the 5,892-mile passage from there to New York. (Courtesy Shore Village Museum.)

Lightships could be moored near shifting shoals where no fixed structure could be placed. Vessels also could be moved when the shifting sands demanded, and moored in deep waters to serve as a landfall for transoceanic shipping traffic. However, being in these exposed positions placed them at high risk from collision. Conditions on these early vessels were close to uninhabitable as the crews were forced to endure rolling and violent pitching and severe storms, resulting in frequent loss of anchors and damage to the vessels. Ultimately, designs would

improve, but the service was not without serious losses. Lighthouse Service records contain 237 instances of lightships being blown adrift or dragged off station in severe weather or moving ice. In addition, monotony and the danger of collision were always present, and 150 collisions were logged with five light vessels lost and many more damaged. Less than a dozen light vessels remain today. A few are preserved as museums, a testimony to the courage and perseverance of their crews. (Courtesy Shore Village Museum.)

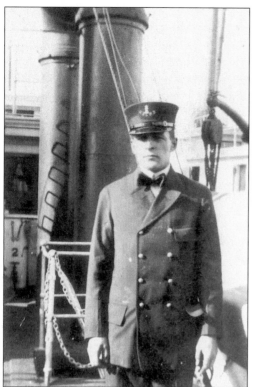

Duty on board Maine's light vessels was rugged at best, but life was rarely monotonous. When storm warnings were flown along the coast and shipping headed for port, the light vessels on Portland Station secured loose gear and settled down to ride the storm out. Light vessels carried a crew of 6 to 17 men and never moved from station unless hurricanes dragged them off. (Courtesy Shore Village Museum.)

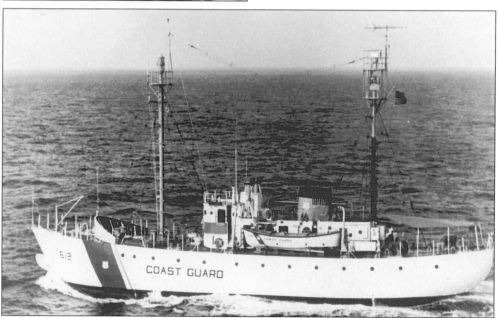

WLV-612 served on the Portland Station from 1971 until 1975, when the Portland Station was discontinued and replaced by a 1004-ton lit navigational buoy. When the WLV-612 left Portland for Nantucket Station, she was one of only three light vessels remaining in service with the U.S. Coast Guard. By 1984, there would be no more, and the era of the light vessel would come to a close. (Courtesy Shore Village Museum.)

First-class lightships with steam fog signals were designed for an outside exposed location and provided with circular daymarks for daytime recognition. Two steam boilers were provided to power a 12-inch steam fog whistle, and a hand-operated 1,000-pound bell was provided as a backup. Illuminating apparatus consisted of two lanterns, each with eight oil lamps and reflectors. Note the lamps within the lantern, each with its chimney protruding above.

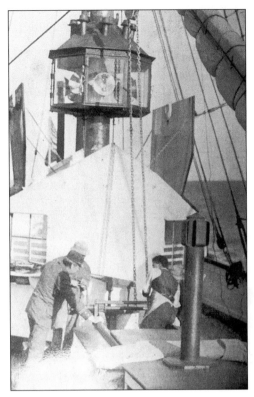

Storms, the ravages of the sea, loneliness, and cold took their toll on sailors who manned these early light vessels. Life on board a New England lightship was anything but placid. While an occasional, warm summer afternoon could be a relief, the unpredictable ocean and New England storms caused great hardships among the crews. Early lightships were cold, damp, and had only the sparest of comforts as most of the space was allocated to fuel and stores.

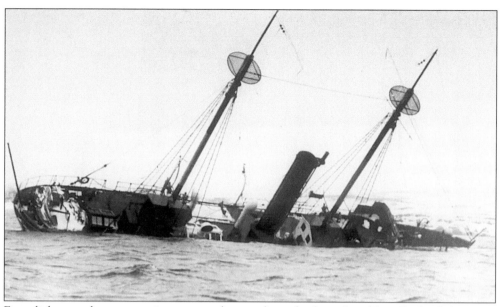

Even light vessels were not immune to damage from the hazardous New England Coast. In 1923, prior to serving at Portland, LV-90 was serving in the second Lighthouse District as a relief. On March 6, she was in transit passing Quick's Hole, Massachusetts, when she struck a submerged rock and sank in the channel. Later, she was raised, repaired, and returned to duty as a relief until 1931, when she was assigned to the Portland Station. (Courtesy Shore Village Museum.)

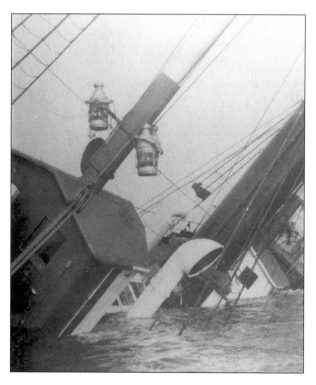

Shown here is a close-up view of the mainmast and lens-lantern lighting apparatus on LV-90 in 1923, before it was raised from Quick's Hole, Massachusetts. Later, in February of 1926, LV-90 was on station as a relief during a northeast gale when boarding seas demolished the port and starboard lifeboats. As the storm continued, heavy seas stove in the pilothouse and pounded away, parting the anchor chain and sending her adrift. (National Archives photo courtesy Shore Village Museum.)

Seven

SOUTH COAST

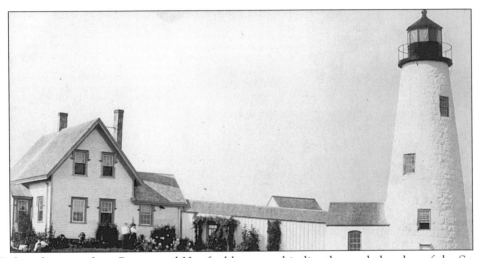

Only a short run from Boston and Hartford by steamship lies the sandy beaches of the South Coast. This area has been famous for centuries for its shipbuilding, and its white sandy beaches are second to none. Near the mouth of the Saco River lies Wood Island. Some years ago, the island was the scene of a murder, and some say the island is still haunted by the ghost of the victim. Lighthouse Keeper Robert Sterling, in his book *Lighthouses of Maine*, tells it this way: In the 1860s, a fisherman from Biddeford Pool, thinking the area good for fishing, moved and built a rough camp on the island. A giant of a man, he also served in the capacity of a special policeman while on the mainland. After living there a while, a young fellow moved into a rundown farm on the west end of the island. Though this squatter had no means of support, he spent much of his time drinking as much liquor as he could beg, and fished and lobstered now and then. When intoxicated, this young man became quarrelsome and this day carried a rifle with him. Seeing this, the fisherman asked for his rifle, which he refused, and a fuss ensued. The fisherman then went home and returned wearing his official police badge, to arrest the offender. As he approached, the drunken man raised his rifle and fired, dropping the officer. The officer's wife dragged him home where he soon died. The squatter later went to the keeper at the lighthouse, where he turned himself in. Some say the ghost of the fisherman still roams the island, patrolling.

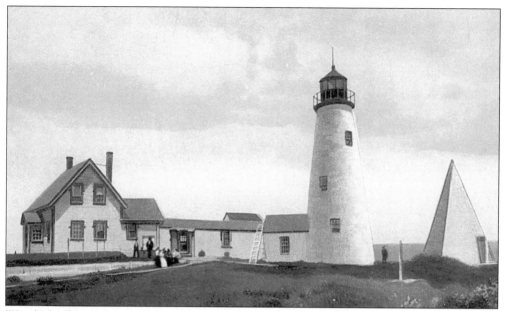

Wood Island Light is one of the older of the Colonial lights, built in 1808 to mark the entrance into Saco Harbor. The light has been a common sight to vacationers at nearby Camp Ellis and Old Orchard Beach for nearly two centuries. Years ago, when mackerel and herring were plentiful in the area, large fleets of seiners could be seen sailing the area. Even today, a sizeable lobster fleet still sails from Camp Ellis. (Reichner view, *c.* 1916.)

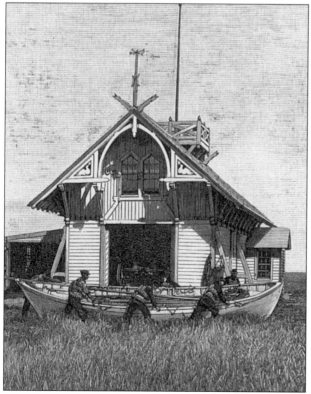

Life-saving stations of the 1870s were typically two-story affairs, measuring from 18 to 20 feet wide by 40 feet long and painted a drab olive color. They were built of tongue-and-grooved pine, with gabled roofs, and covered with cedar and cypress shingles, with strong shutters to the windows. The roof bears heavy projected eaves and a small lookout deck from which spires a flag staff. (Fletcher's Neck Station, *Harper's Weekly*, March 27, 1886.)

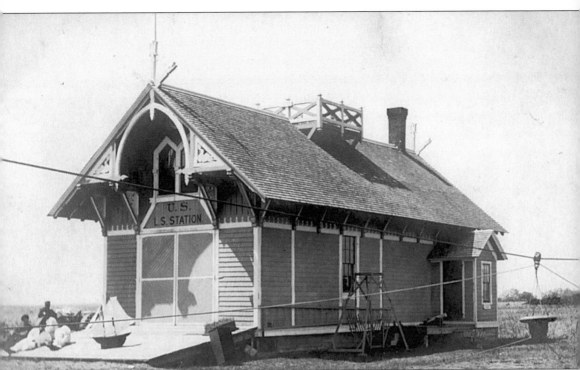

The Fletchers Neck Life-Saving Station at Biddeford Pool was erected in 1873. During this year, the first major expansion of the Life-Saving Service occurred since its organization in 1848, with six stations being established in Maine and New Hampshire. The stations were all quite similar in appearance. Station keepers were required to live at or near the stations year round, while surfmen were released during the calmer summer months (from May until September). From September 1 until November 30, the station employed six surfmen, with the addition of a seventh "winter man" from December 1 until April 30. In 1904, a new station was built at Fletcher's Neck, on the same lot, to replace the 1873 station. Today, they both remain, nicely restored and used as a private residence. This is one of the few examples of both stations still existing together in the United States and is a treasured landmark.

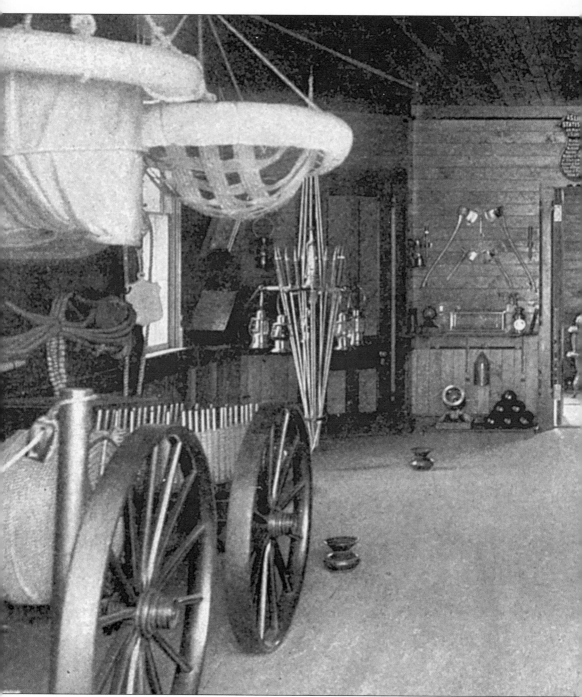

The boat room in the early life-saving stations occupied over two-thirds of the ground floor, opening by a broad double door to the weather. Here were stored the boats, life car, wreck gun, and additional apparatus. An 1880s station, fully equipped, cost about $5,000 and included all appurtenances needed as well as being furnished with stoves, cots, blankets, and required utensils. Stations were provided with the most approved appliances for saving lives from wrecks, first among these being the six-oared surfboat. Surfboats were usually made of cedar and

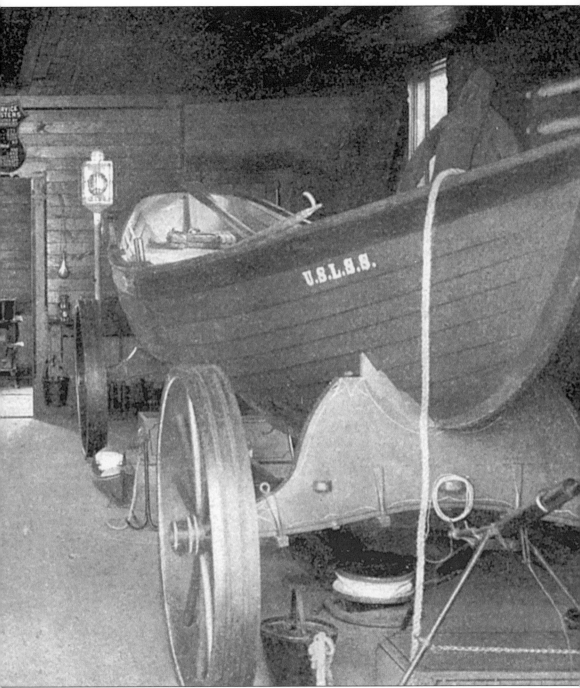

generally measured from 25 to 27 feet long. Commonly, air-cases were included within the ends to provide floatation, and cork fenders ran along the sides to protect against collision with wreckage. Boats generally weighing from 700 to 1,000 pounds are rowed by six skilled surfmen and are guided by the station keeper using a long steering oar. So great was the skill of the men in the Life-Saving Service that thousands of mariners were brought to safety in such craft.

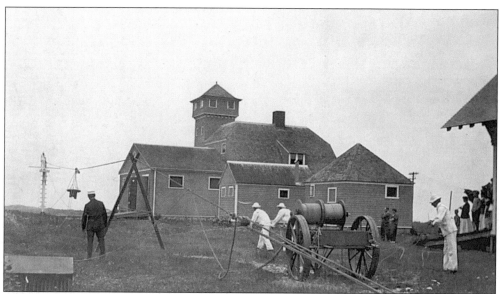

The breeches buoy apparatus was used to rescue sailors when their vessel was stranded close enough to shore to be reached by a shot line from the life saver's Lyle gun. Drills were held daily (except Sunday) in this and all aspects of rescue work, flag signaling, first aid, restoration of the apparently drowned, and other requirements, insuring that the men would be proficient under all conditions. Shown is the Fletchers Neck crew drilling, *c.* 1900.

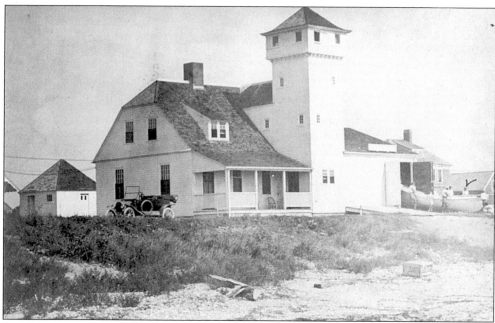

The 24th day of June 1899 dawned warm and sunny and the men of the Fletcher's Neck station were on watch in the tower when the keeper heard the cries from two men caught in a sudden rain squall one-half mile northeast. The crew launched their dory and pulled with all possible haste to the men, who were clinging to the bottom of the overturned craft. The crew hauled them to safety, returning to shore with the sailboat in tow.

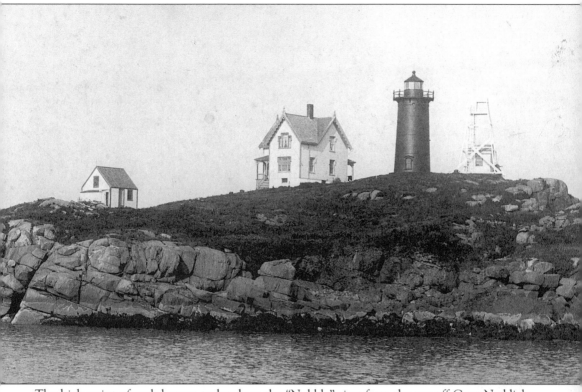

The high point of rock known to locals as the "Nubble" rises from the sea off Cape Neddick Point in the Town of York. Separated from the mainland by a narrow channel, Nubble Light Station has been a popular destination for both summer and winter visitors since its construction in 1879. The station was recommended to Congress following the wreck of the steamer *Isadore*, which was lost with all hands within sight of the Nubble. For years, the lighthouse at Cape Neddick has been considered the essence of New England lighthouses and has found its way onto calendars, note cards, and publications around the world, as well as being the subject of thousands of paintings. When first constructed, the cast-iron tower was painted brown and separated from the dwelling. Nathaniel Ottersen was appointed the first keeper here and served until 1885 at a salary of $500 per year. Some time after 1904, while William Brooks was keeper, the covered walkway was constructed connecting the light tower to the dwelling so he could easily tend the light during severe winter storms. (Henry G. Peabody view, *c.* 1885.)

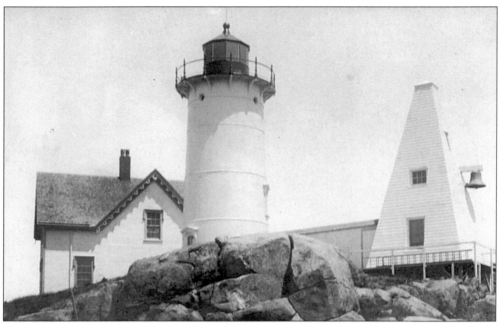

Around the turn of the century, the cast-iron light tower at Cape Neddick was repainted white for increased visibility, and the fog bell tower was rebuilt and enclosed. Since its establishment in 1879, the tower here has shown a fixed, red, fourth-order light. The original 1,226-pound fog bell, struck by machine every 30 seconds during times of fog, remained in service until 1961.

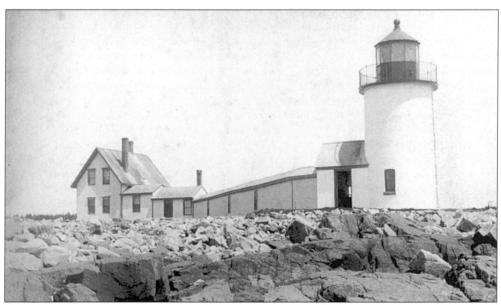

The lighthouse on Goat Island marks the north side of the entrance to Cape Porpoise Harbor. The harbor entrance is both narrow and crooked so a light was constructed here in 1833. A fixed white light of the sixth order has shown here since 1859, when the present tower was constructed. The keeper's quarters, oil house, and boathouse still survive and are on lease to the Kennebunkport Conservation Trust. The tower was automated in 1990.

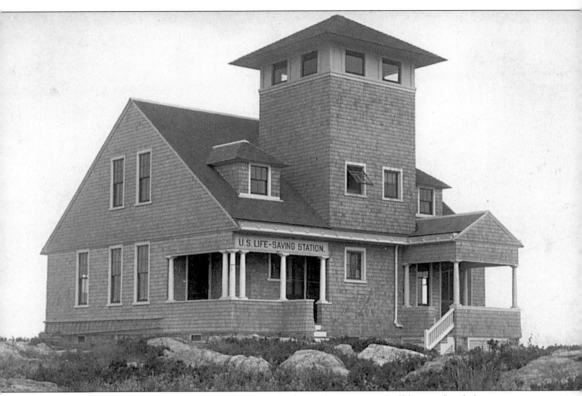

The Maine and New Hampshire boundary passes through a group of offshore islands known as the Isles of Shoals, for centuries a haven for sailors and yachtsmen traveling the coast. Despite the island's inviting appearance in the summer, the area has seen many severe storms, necessitating the establishment of a life-saving station among the group. Assumed by many to be in New Hampshire, the island of Appledore is indeed under Maine jurisdiction. It was here that lighthouse keeper Thomas B. Laighton built his grand hotel and lived out his remaining years after his retirement from White Island Light. The 1910 life-saving station here is of an unusual design, one of only three built in the country. This design is known by today's historians as the "Isles of Shoals Type," and it served as a model for the Peaked Hill Bars station on Cape Cod. Note the rather large box-like lookout tower and the second porch entrance. (St. Clair photo, c. 1910.)

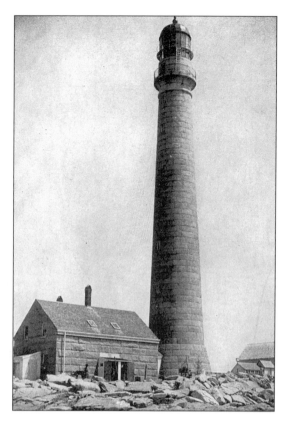

Five miles southeast of Cape Neddick lies a flat stretch of rock surrounded by ledges known as Boon Island. This isolated outpost was known to the keepers there as one of the most dangerous on all the Maine Coast. In 1800, the first wooden light tower was constructed, lasting only three years until it was washed away in a winter storm. In 1812, the new tower of gray granite was authorized, rising 133 feet above the sea.

After another great storm in 1831 damaged much of the tower, today's 137-foot tower was constructed. Keepers at this remote station suffered greatly from their isolation, buffeting winds and cruel storms. Often, the keepers and their families could be marooned for several weeks by storms and fog. Many times, supplies would began to dwindle, forcing the keeper to attempt the trip in his small boat to the mainland. Shown here is keeper Charles Williams and his family, c. 1904. (Courtesy Andy Price collection.)

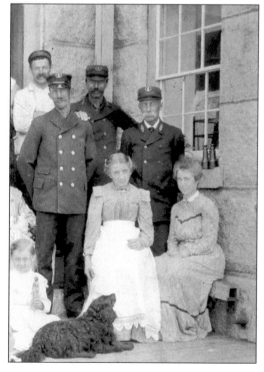

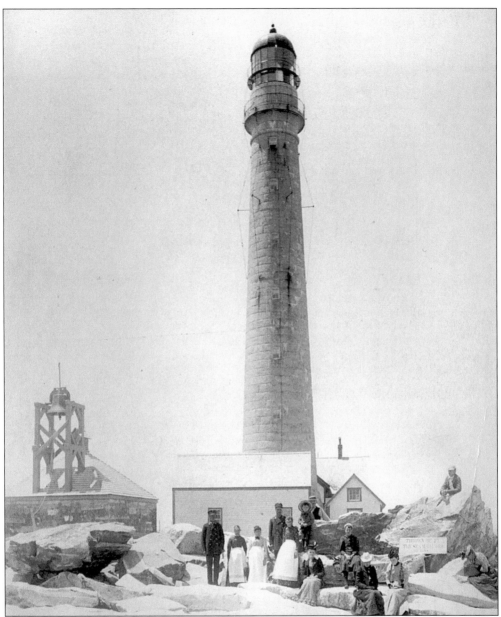

No keeper has spent more time on this storm-beaten ledge than William W. Williams. Keeper Williams was stationed here in the 1890s and remained with his family for 27 years. When rough weather comes to the island, the seas can clean the entire ledge off, forcing the keepers and their families to take refuge in the light tower, sometimes for days at a time. Occasionally, storms could provide an unexpected bounty, as Keeper Williams discovered one Thanksgiving. As the holiday approached one season, no supplies had been received for several weeks and the family pondered over what they might prepare for the holiday feast. Suddenly, a loud crash was heard up on the lantern deck, followed by additional bangs. As the keeper climbed the long winding stairs to the lantern, he discovered eight black ducks, who, blinded by the lantern's bright beam, struck the lantern glass. Through the evening, as additional birds met a similar fate, the family's holiday needs were filled. (W.N. Gough photo, c. 1880.)

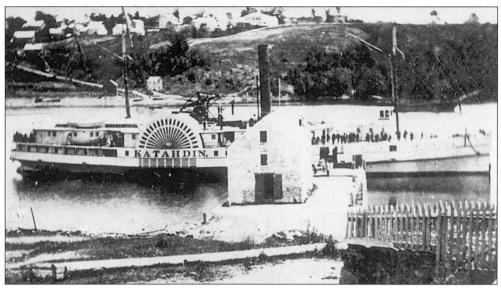

On January 9, 1886, as a gale raged along the coast, the side-wheeled steamer *Katahdin* was attempting the passage to Boston. Running along by Cape Porpoise, she attempted to head for the shelter of Boon Island but could make no headway and was running out of fuel. Her crew quickly began to use her cargo for fuel and soon they were dismantling the staterooms. Just as the wood was nearly exhausted, a wind shift allowed them to gain headway and limp into Portsmouth Harbor.

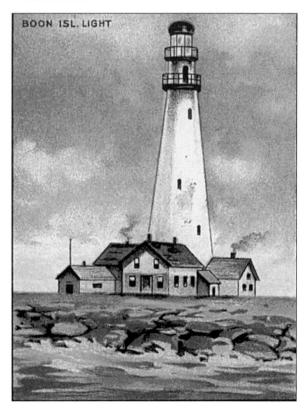

BOON ISL. LIGHT

Early lighthouse appointments were often more influenced by politics than by ability. On May 17, 1853, the *Portland Daily Advertiser* noted that the keeper of Boon Island Light, who reportedly put out the light at midnight "to save the ile [oil] was a democrat . . . and transported from the interior of New Hampshire, where he had never seen a vessel . . . and supposed that vessels . . . did not sail after dark." Shown is a 1912 Boon Island cigarette card from a Hassan series of 50.

Eight

NEW HAMPSHIRE

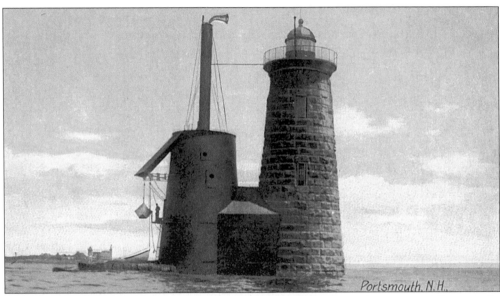

Portsmouth. N.H.

Whaleback Light rises out of the sea on the northeast side of the outer entrance to Portsmouth Harbor and the Piscataqua River. The station was built in 1829 and is one of the more remote posts on all of the coast. The first light here was built on the ledge, on a stone pier 22 feet high. As seas swept over the top of the light, it was not long before the tower leaked badly. A sheathing of wood was placed around the tower to keep it from being flooded out completely, but soon it was discovered that fundamental defects in the foundation doomed the entire structure. Even furniture slid across the floors as waves pounded the structure, but it was not until 1869 that Congress took action. The new tower was constructed next to the old, at a cost of $75,000. This sturdy granite structure was 75 feet high and withstood many gales, though not without incident. In 1886, heavy seas during a blow battered in one of the heavy windows of the 5-foot-thick walls, filling the living quarters with water and nearly drowning the keepers; they barely escaped to the upper level. There the keepers were forced to hoist their blanket to the masthead as a signal of distress. (Hugh C. Leighton view, c. 1910.)

Portsmouth Harbor or Newcastle Light was the first lighthouse to shine in New Hampshire. The first beacon, erected in 1771, was established at what was then called Fort William and Mary, and consisted of a lantern hoisted up the flagpole. The cost of maintaining this crude light was borne by the vessels that were guided into the harbor. The first regular lighthouse was placed in operation sometime in the 1780s with Capt. Titus Salter as appointed keeper. By 1790, the keeper's position was made full time and he resided at the light, being paid the sum of $3.46 per week. By 1800, the light tower was found to be deteriorating and repairs were made, raising it to a height of 80 feet above the water. Soon, however, this tower too had difficulties. The firing of the large cannon at the fort, now called Fort Constitution, began to crack the lantern windows and to crack the walls of the keeper's dwelling, and by 1809, the dwelling was finally moved. In 1829, more difficulties were encountered as a fire broke out in the lantern, threatening the fort and causing serious damage to the lantern.

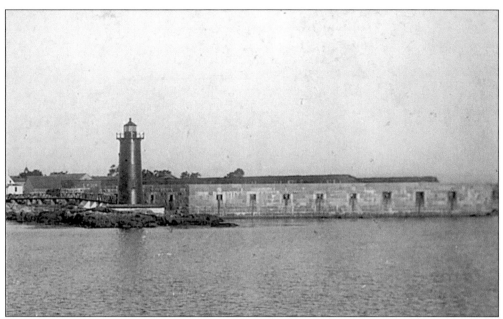

Though the old tower was well constructed and lasted for 68 years, a new structure was needed by the 1870s . The new tower, constructed entirely of iron, stood 52 feet above the water. One of the keepers here, Capt. Henry Cuskley, retired in 1941 after serving 44 years with the Lighthouse Service, one of the longer tenures on record. Keeper Cuskley served at Cape Elizabeth Light, Libby Island Light, and then at Seguin before coming to Portsmouth in 1915.

During the period from the 1890s to the 1920s, many local scenes were produced on china pieces for sale to tourists. China pieces range from plates to cups, from creamer and sugar sets to pin plates and napkin holders, and feature scenes from all over the country. Lighthouse and life-saving scenes today bring a premium and are most collectible. Pictured is a c. 1900 Whaleback Lighthouse commemorative creamer from the author's collection.

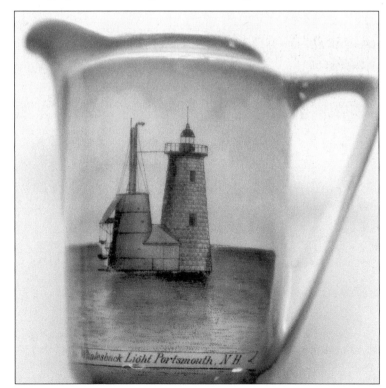

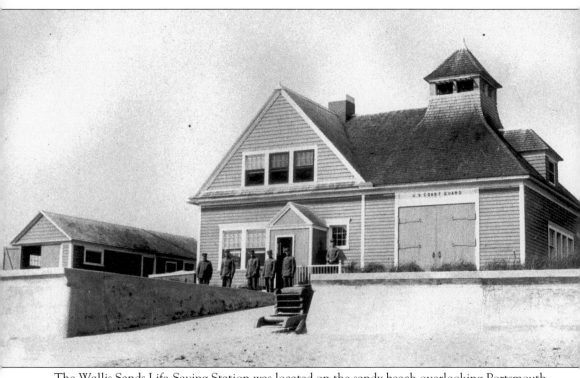

The Wallis Sands Life-Saving Station was located on the sandy beach overlooking Portsmouth Harbor. Strandings here were not uncommon, and February 9, 1896, was no exception. During a thick snowstorm, the Wallis Sands crew was notified of the stranding of the British schooner *Glendon*. At the same time, the Rye Beach life savers had loaded their beach apparatus and started for the scene. After traveling 9 miles, the crews met and proceeded to make ready. It being impossible to launch a boat in the violent seas, a shot from the Lyle gun was fired. Though the shot hit its mark, no effort was made on the vessel to haul the hawser aboard and a second line was fired. Again, no effort was seen on board. Following a third shot, the crew on board the ship found the hawser and soon the breeches buoy was rigged. The seven crewmen were landed with no time to spare as the wreck was driven to pieces in the breakers. (Coast Guard photo, *c.* 1916. Courtesy Ralph Shanks collection.)

The life-saving station at Jerrys Point on Great Island in Portsmouth Harbor was constructed in 1887. In 1907, the property on the island was reclaimed by the War Department and the life-saving crews forced to move into rented space, and later into the new Portsmouth Harbor station on Wood Island in Maine. Today, the Jerrys Point station still stands, having fallen victim to the elements, neglect, and vandalism. Without help, this station will soon be lost as well.

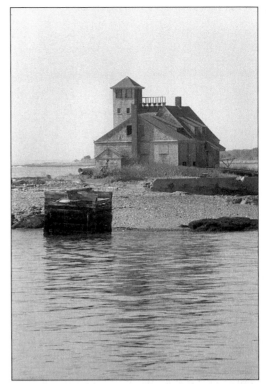

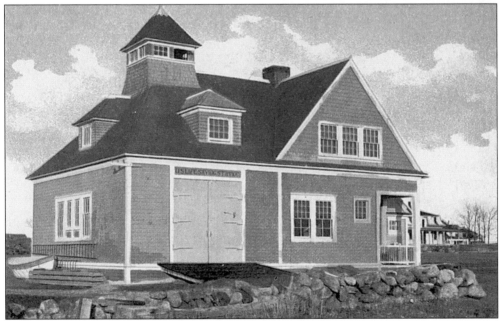

Locke's Point is located at the north end of Rye Beach, halfway between Portsmouth and Hampton Beach. The first life-saving station here was erected in 1874 and served until it was replaced in 1890. At one time, there were four life-saving stations along this 13-mile stretch of coastline, making this one of the most densely protected coastlines in America. (Hugh C. Leighton view, c. 1916.)

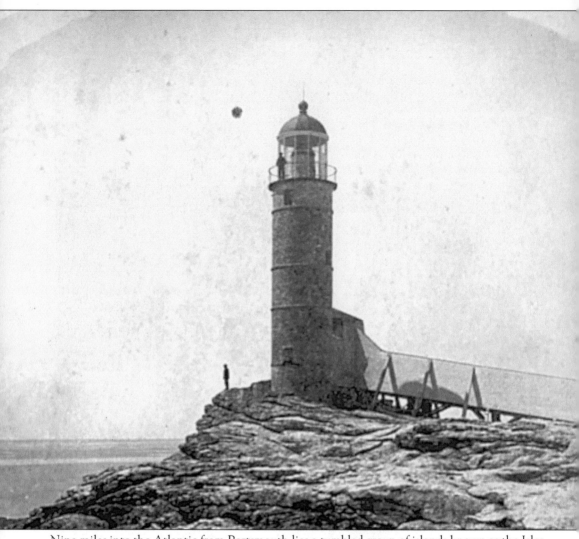

Nine miles into the Atlantic from Portsmouth lies a tumbled group of islands known as the Isles of Shoals. Long before the boundary between Maine and New Hampshire divided the group, pirate Captain Kidd is said to have buried his treasure on this storm-tossed group. In 1839, Thomas B. Laughton moved to White Island, chief among the group, along with his wife and two children, to become keeper of the Isles of Shoals lighthouse. In December of that same year, daughter Celia and her mother were lighting the lamps during a fierce blizzard when they heard a ship's signal cannon. Bound for Newburyport, the brig *Pocohantas* was lost in the gale and soon met her fate on the sands of Plum Island, Massachusetts, with the loss of all on board. Over the years, Keeper Laighton began to busy himself with the construction of a great hotel on nearby Appledore as Celia remained to tend the lighthouse. Years later, Celia would write a number of wonderful books describing her years with her father when they lived at and tended the Isles of Shoals light. (William N. Hobbs photo, *c.* 1880.)

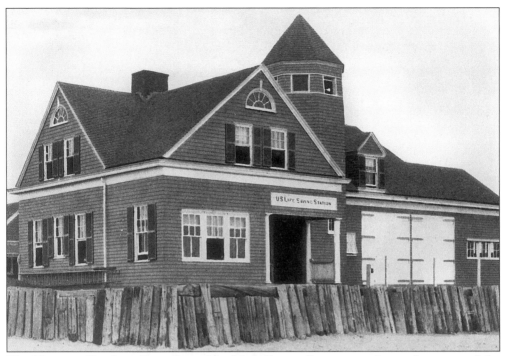

The Hampton Beach or Great Boars Head Life-Saving Station was the southernmost of the New Hampshire stations. Built in 1898, the station was of an unusual design for New England stations, being one of only eight known as the "Jersey Pattern." The boat room at the Hampton Beach station was typical of most stations of the era and housed all manner of equipment for use in rescuing crews of vessels in peril. (Courtesy Ralph Shanks collection.)

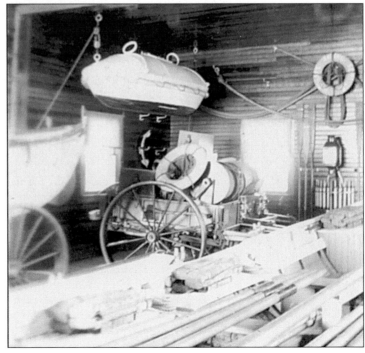

Shown is the boat room in 1911. In the foreground is the seven-man surfboat with six pulling oars and one long steering oar neatly stowed across the seats. Note the cork life vests stored along the gunwales for each of the men. To the left can be seen a similar surfboat on the beach carriage. Behind is the beach apparatus cart with equipment for breeches buoy rescue, and hanging from the ceiling is a Francis metallic surfboat.

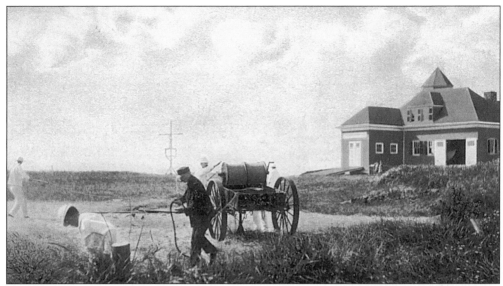

In June 1903, the Hampton Beach life savers noticed five fishing boats moored 400 yards offshore, in danger of being wrecked by a gale. In rough seas, the keeper and a temporary crew of fishermen manned the surfboat and put out toward the craft. While in route, a fisherman fell overboard and was swept into the surf. The keeper rescued the exhausted man and revived him by practicing the Life-Saving Service method of "restoration." All of the boats were saved. (Robbins view, c. 1910.)

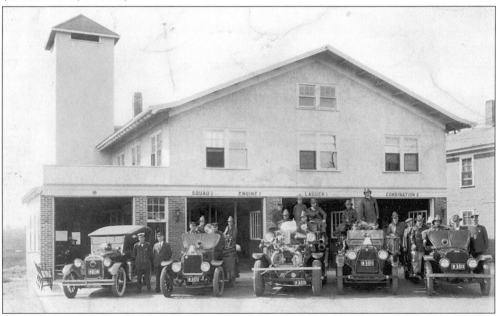

Shown in this wonderful 1920s photo is the Hampton Beach Fire Department. Included are Chief H.B. Whiting, Deputy Chief J.C. White, and Lieutenants Huckins and G.H. Lamott II. The department enjoyed a fine compliment of apparatus, including an Ahrens Fox and a White pumper. Note the similarity between this station, with its tall hose tower, and many of the life-saving stations. The hazards encountered by each group are similar and they all truly deserve the title "heroes."

The Lighthouse Keeper's Lament

O what is the bane of a lightkeeper's life
That causes him worry, struggle and strife,
That makes him use cuss words, and beat his wife?
It's Brasswork.

The lamp in the tower, reflector and shade,
The tools and accessories pass in parade.
As a matter of fact the whole outfit is made
Of Brasswork.

The oil containers I polish until
My poor back is broken, aching; and still
Each gallon and quart, each pint and each gill
Is Brasswork.

The machinery, clockwork, and fog-signal bell,
The coal hods, the dustpans, the pump in the well.
Now I'll leave it to you mates, if this isn't—well
Brasswork

So it goes all the Summer, and along in the Fall,
Comes the district machinist to overhaul
And rub dirty and greasy paws over all
My Brasswork.

And again in the Spring, if perchance it may be
An efficiency star is awarded to me,
I open the package and what do I see?
More Brasswork.

And when I have polished until I am cold
And I'm taken aloft to the Heavenly fold
Will my harp and crown be made of pure gold?
No, Brasswork.

—Fred Morong, U.S. Light House Service
(From Robert T. Sterling's 1935 publication entitled *Lighthouses of the Maine Coast and the Men Who Keep Them.*)

Bibliography

Alvord, Douglas. *Damariscove Station*. Island Journal. Rockland. Volume 2, 1985. Pp. 60–63.

Bachelder, Peter. *Lighthouses of Casco Bay*. Portland: The Breakwater Press, 1975.

_____, *Maine Lighthouse Map & Guide*. Freeport: Hartnett House Map Publishers, 1998.

Claflin, James. *Lighthouses and Life Saving Along the Massachusetts Coast*. Charleston: Arcadia Publishing, 1998.

Clifford, Candace. *Inventory of Historic Light Stations*. Washington, DC.: National Park Service, 1994.

Holland, Francis Ross, Jr. *America's Lighthouses–Their Illustrated History Since 1716*. Brattleboro: The Stephen Greene Press, 1972.

Kimball, Sumner I. *Report of the General Superintendent of the Life-Saving Service Relative to the Claims of W.A. Newell as the Originator of the System of the Life-Saving Service of the United States*. Washington: Senate Document No. 270, May 18, 1898.

Labrie, Rose. *Sentinel Of The Sea . . . Nubble Light. A History of Cape Neddick Light Station*. 1958.

Moulton, John K. *The Portland Observatory: The Building, The Builder, The Maritime Scene*. Yarmouth, Me., Landmarks, 1989.

na. *Cape Elizabeth—Past to Present*. Cape Elizabeth: Cape Elizabeth Historical Preservation Society, 1991.

na. "The Life-Saving Service." *Harper's Weekly*, March 27, 1886. "Christmas-Eve in a Light-House." *Harper's Weekly*, December 30, 1876.

na. "Launching The Life-Boat." *Collier's Weekly*, December 24, 1898.

na. "The United States Life Saving Service." Scientific American Supplement. February 6, 1892.

na. *Along the Coast, Maine and the Maritime Provinces*. Boston: Eastern Steamship Company.

O'Connor, William D. *Heroes of the Storm*. Boston: Houghton, Mifflin and Company, 1904.

Quinn, William P. *Shipwrecks Along the Atlantic Coast*. Orleans: Parnassus Imprints, 1988.

Shanks, Ralph and Wick York. *The U.S. Life-Saving Service*. Petaluma: Costano Books, 1996.

Snow, Edward Rowe. *Famous New England Lighthouses*. Boston: The Yankee Publishing Co., October 1945.

_____, *Great Storms and Famous Shipwrecks of the New England Coast*. Boston: The Yankee Publishing Co., December 1944.

Sterling, Robert Thayer. *Lighthouses Of The Maine Coast and the Men Who Keep Them*. Brattleboro: Stephen Daye Press. 1935.

Thompson, Frederic L. *The Lightships of Cape Cod*. Northborough: Kenrick A. Claflin & Son, 1996.

U.S. Coast and Geodetic Survey. *United States Coast Pilot, Atlantic Coast, Section A, St. Croix River to Cape Cod*. GPO, 1933.

U.S. Coast Guard. *Annual Reports*. Washington: G.P.O., 1914–1926.

U.S. Life-Saving Service. *Annual Reports*. Washington: G.P.O., 1876–1914.

_____, Mortar and Beach-Apparatus Drill. Washington: G.P.O., 1880.

_____, *Regulations for the Government of the Life-Saving Service of the United States*. Washington: G.P.O., 1899.

U.S. Light-House Establishment [Service]. *Annual Reports*. Washington: G.P.O., 1846–1938.

York, Wick. *Saved! History of the Life-Saving Service in Maine*. Island Journal. Rockland. Volume 2, 1985. Pp. 56–59.

For additional reading, the above original vintage titles and many others are available from Kenrick A. Claflin & Son Nautical Antiques, 30 Hudson Street, Northborough, MA 01532 (Tel. 508-393-9814).

For further information about our lighthouses and Life-Saving Service and Coast Guard, please contact the following organizations:

United States Life-Saving Service Heritage Association, P.O. Box 75, Caledonia, MI 49316-0075

United States Lighthouse Society, 244 Kearny Street, San Francisco, CA 94108

Shore Village Museum, 104 Limerock Street, Rockland, ME. 04841 (Tel. 207-594-0311)

The New England Lighthouse Foundation, P.O. Box 1690, Wells, ME 04090